IMAGES
of America

DIXON

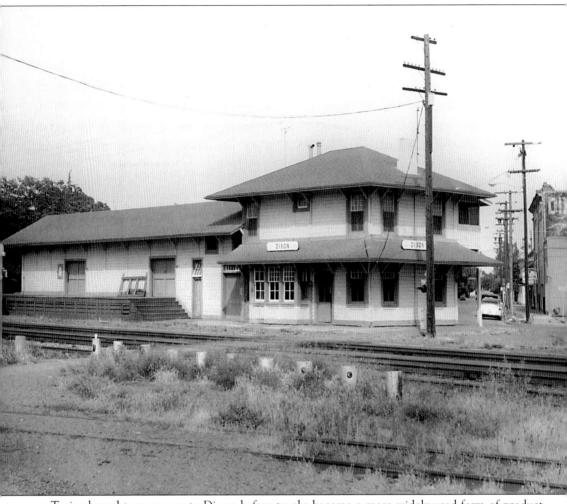

Trains brought commerce to Dixon before trucks became a more widely used form of product transportation, while passenger trains made stops several times a day to pick up and drop off travelers. For many years, John Marker was the station agent in charge and lived upstairs with his family. This Dixon Train Depot, built in 1885, was a landmark before it was finally torn down in 1969. (Courtesy of Harold Axelson.)

ON THE COVER: This Dixon parade took place c. 1890.

IMAGES
of America

DIXON

Dixon Women's Improvement Club

ARCADIA

Copyright © 2005 by Dixon Women's Improvement Club
ISBN 0-7385-2972-9

Published by Arcadia Publishing
Charleston SC, Chicago IL, Portsmouth NH, San Francisco CA

Printed in Great Britain

Library of Congress Catalog Card Number: 2005921748

For all general information contact Arcadia Publishing at:
Telephone 843-853-2070
Fax 843-853-0044
E-mail sales@arcadiapublishing.com
For customer service and orders:
Toll-Free 1-888-313-2665

Visit us on the internet at http://www.arcadiapublishing.com

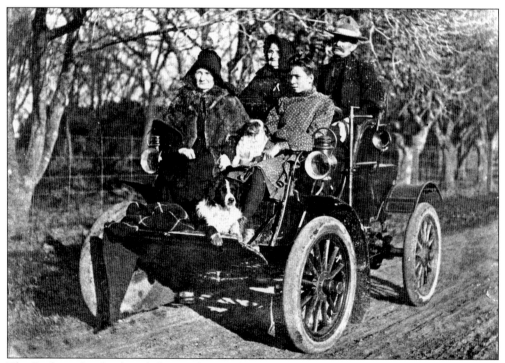

The Dickson family, from left to right, are (front seat) Mrs. Elizabeth Dudley, age 65, oldest daughter of Jane and Thomas Dickson; and Hazel Bee Dudley, daughter of Delmar Dudley, great-granddaughter of Jane Dickson, age 9; (back seat) Mrs. (Jane) Thomas Dickson, age 86; and Earl D. Dudley, age 40, son of Mrs. Elizabeth Dudley and grandson of Jane Dickson. Note that Earl is driving in the back seat behind Hazel. Can you see the steering wheel?

CONTENTS

ACKNOWLEDGMENTS

We are deeply indebted to our editorial committee, who worked countless hours this past year in preparing this book. Described as "reluctant volunteers," they admit that the days and nights working on the history of Dixon became a labor of love. We wish to acknowledge Arlene Ernst, who acted as project coordinator, text writer, and editor, and Mary Jane O'Neill, who served as technical director, writer, and editor, both of whom devoted untold hours planning, coordinating, and arranging the contents of this book. A very special thank you to Ardeth Sievers Riedel, historical research technician and writer; Shirley Parsons, Dixon Public Library archivist and writer; and Barbara Rayn Beckworth, writer and editor.

This photographic journey through Dixon would not be possible without the many contributions from its citizens. We deeply appreciate those who have generously allowed us to reproduce their personal pictures, which offer an invaluable insight into our history, including the Dixon Public Library, Dixon Fire Chief Rick Dorries, *Dixon Tribune*, Hometown Market, Greg Atkins, Harold Axelson, Joan Axelson, Carlene Fanning Blalock, Jan Bock, Alan Brown, Heidi Brown, Beth Franks, Norman George, Bob Gill, Roy Gill, Virginia Null Hendrix, Marda Rowe Henry, Phyllis Watson Houlding, Joanne Jacobs, Wes Jacobs, John Lofland, Nancy Madden, Grace O'Neill, Steve O'Neill, Pat Pipkin, Latoyia Reeb, Bud Rossi, Di Rossi, Alan Schmeiser, Larry Simmons, Greta Thomsen, and Lucy Vassar. We also wish to thank Jacob Story for the loan of his laptop computer, which proved to be an absolute necessity.

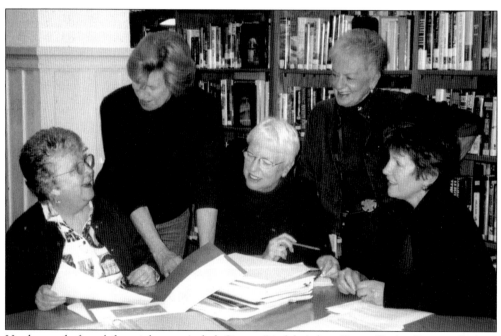

Hard at work, from left to right, are Ardeth Sievers Riedel, Arlene Ernst, Shirley Parsons, Barbara Rayn Beckworth, and Mary Jane O'Neill. Contact information: Historical Project, Dixon Women's Improvement Club, P.O. Box 25, Dixon, CA 95620. E-mail: MaryJane@omsoft.com (Joan Axelson photo.)

INTRODUCTION

The history of the City of Dixon goes back to the township of Silveyville, which once had great expectations for its future. The settlement began as a stagecoach stop and Pony Express route on today's Silveyville Road, where Elijah Silvey built a small town seeking would-be miners looking for food, drink, and perhaps overnight lodging. A swinging red lantern was hung on the porch of the tavern to attract travelers' attention. By 1860 Silveyville had a store, a saloon, a school, two churches, a blacksmith and drugstore, and homes for 160 residents. But all that changed because of a railroad, and today Silveyville is only a small historical marker reminding us of its existence.

The demise of Silveyville and the emergence of Dixon had everything to do with the California Pacific Railroad. Thomas Dickson, a farmer and self-proclaimed minister, came by covered wagon to California from Iowa in 1853 at the age of 53, bringing with him 12 head of oxen, 3 cows, 3 wagons, some horses, 4 children aged 7 to 10, and a pregnant wife. The Dicksons and two other families, the McFadyens and the Van Sants, farmed the land and established a general store and post office.

In 1868 the California Pacific Railroad planned a line to run directly through the small settlement known as "Dicksonville," narrowly bypassing Silveyville. Thomas Dickson, a prosperous farmer by then, donated 10 acres to the project. Legend has it that when the first consignment of literature and timetables for the new station arrived, the town's name was spelled "Dixon." Rather than demand a reprint, Dickson good naturedly permitted the misspelled name to remain.

The official founding of Dixon took place in 1868. In anticipation of the commerce expected to be generated by the rail line, buildings were constructed near the station site, and many of the residents of Silveyville and surrounding areas relocated to Dixon. Huge log rollers, gangs of men, and 40-mule teams were employed to move the town. Only on such flat land could this have been accomplished. The logs were placed under each building and, as they were pulled forward, the men seized the log emerging from the back and place it up front. By 1871 every movable building in Silveyville had reportedly been transported to Dixon. (Even the graves in the Silveyville Cemetery were exhumed and moved. That is why Dixon's cemetery is called Silveyville Cemetery.) One of the relocated buildings was the Methodist church, which continued to hold services every Sunday while en route. Now located on Jackson and B Streets, this church is considered a historical landmark and still has an active congregation.

By 1870 the town was thriving, with 317 inhabitants, 40 businesses, and land parcels that were selling for $400 and $500. In 1874 the Bank of Dixon and the *Dixon Tribune* office opened for business and by 1877 Dixon had a population of 1,200 residents. The downtown area included the newspaper office, seven hotels, eight saloons, two livery stables, four general stores, two jewelry stores, two millinery stores, two butcher shops, three blacksmith shops, one manufacturer, one cabinet maker's shop, one lumber yard, four grain warehouses, and a flour mill. On March 30, 1878, Dixon's city government was established and a board of trustees was appointed.

By 1885 downtown Dixon had a wider variety of businesses than exist in the same area today. Eppinger's, which later became Schulze's Department Store, sold plows, harrows, canned goods, meat, hardware, yard goods, overalls, and saddles. Farmers were billed annually.

Steinmiller's made and repaired harnesses and drapers for harvest, the draper being the canvas conveyor belt, which needed constant repair. Livery stables were abundant. There were blacksmith shops for shoeing horses, shrinking steel tires onto wagon wheels, and pounding out plowshares. One of the blacksmiths was also an undertaker, and coffins were regally carried to the cemetery in his horse-drawn hearse.

The top floors of three buildings on Main Street were used for fraternal organizations: Masons, IOOF (International Order of Odd Fellows), and the Redmen. The IOOF frequently

provided loans, thus also acting as a bank. Barbershops flourished. Since hot water was rationed on the farms (saved for coffee, washing clothes, and scalding pigs to remove their bristles) the barbershops provided back rooms with tubs of hot water for bathing.

There were more saloons than churches in Dixon during those early years. By 1877 Dixon boasted 12 bars and 5 churches. Fisher's Saloon was one of the quieter bars, while McDermott's "Fly Trap" beckoned the rowdier crowd. "Bawdy houses" were in evidence, as could be expected in a community where much of the farm labor was provided by single men.

Dixon's Opera House, with seating for 600, was located on B Street between North First and Jackson. A variety of entertainment was offered, but none was more unusual or more popular than the performance of Miss Millie Christine, whose billing name was the Two-Headed Nightingale. She had two separate heads and shoulders, which blended into one body to form one person. She had four perfect legs and feet, and walked on two or four as she pleased. Legend has it that she was a splendid singer: one voice a soprano, the other an alto.

By the 1920s, Dixon was known nationally in agricultural circles for the number and quality of its sheep. At one time, Dixon was home to two of the three slaughterhouses west of Denver, Colorado.

In the early 1900s, after irrigation pumps became available, alfalfa flourished, which provided more feed for dairy cows so that within a few years Dixon became known as the "Dairy City." At one time, Dixon had over 80 dairies. The dairy that put Dixon on the map was the Timm Certified Dairy, which was originally known as the "World's Largest Certified Dairy" operating with over 300 cows. These dairies provided milk to the Bay Area and Sacramento, and also supplied milk to the Southern Pacific Railroad diner.

In 1883 Dixon was consumed by a great fire in which most of the downtown was destroyed. However, the catastrophic earthquake of 1906, which devastated San Francisco, left Dixon untouched. The citizens of Dixon came to the aid of victims of the disaster. Food, including 500 loaves of bread along with 12,000 hard-boiled eggs, was sent to feed the needy. Through the efforts of the Dixon Women's Improvement Club, arrangements were made to house and care for the infants of a San Francisco orphanage that had been totally demolished. Facilities were graciously donated in order to create a safe indoor living and play environment for these young guests.

Maintaining law and order in pioneer towns like Dixon fell to dedicated law enforcement officials. The constables, marshals, deputies, sheriffs, and police of the early years faced a wide array of enforcement challenges. Examples of these challenges can be seen in the following Dixon ordinances, c. 1880–1890:

> Ordinance No. 22: Unlawful to keep a place where opium is smoked: amended to include all smokers of opium. (Passed May 3, 1881.)

> Ordinance No. 36: Indecent Exposure of Animals used for Propagation Purposes. Any stallion or jack used to service any mare . . . must be in an enclosed barn, the openings and seams between the boards of said barn must be perfectly closed and secure from the public gaze. (Passed May 6, 1884.)

In its early years, Dixon was known for grain, alfalfa, dairy and sheep farming. Today Dixon, a town still rich in agricultural roots, supports a population of 18,000. Home to the annual Lambtown, U.S.A. Festival, Dixon has a well-deserved national reputation as a leader in the sheep industry. Dixon is also the home of the Dixon May Fair, the oldest fair in California. Pastoral Dixon is blessed with a mild climate, thousands of acres of open space, many neighborhood parks, and excellent schools, as well as close proximity to a major university.

One
EARLY DAYS

In 1868, the United States was experiencing a burst of expansion following the terrible destruction of the Civil War. In Solano County, the California Pacific Railroad planned a rail line that narrowly bypassed the town of Silveyville, population 150, and crossed the land of Thomas Dickson, a local minister, school teacher, and farmer. When the tracks were nearly completed, Dickson donated 10 acres of land for the depot and a city to be named after him: Dicksonville. The station was built, but human error, the spoiler of many men's grand dreams, came about when the first rail shipment of merchandise arrived in 1872 mistakenly addressed to "Dixon." That spelling has remained.

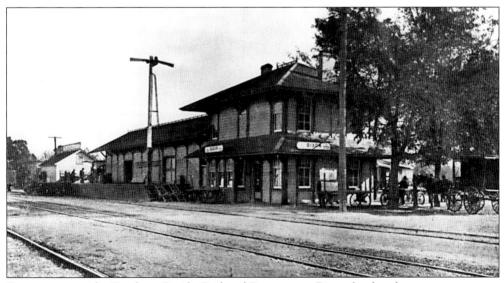

For many years, the Southern Pacific Railroad Depot was a Dixon landmark.

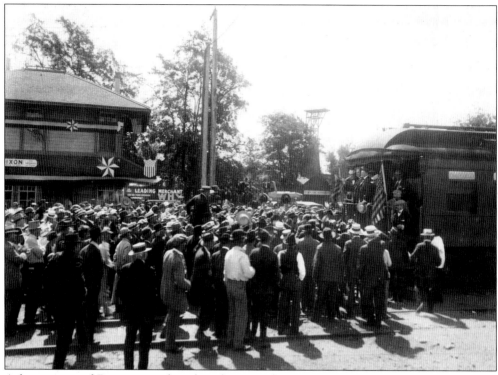

A large group of Dixonites gathered at the train depot to greet a presidential candidate, an event which took place west of the tracks facing B and Jackson Streets. The depot was on the left, and the fire alarm tower can be seen in the distance.

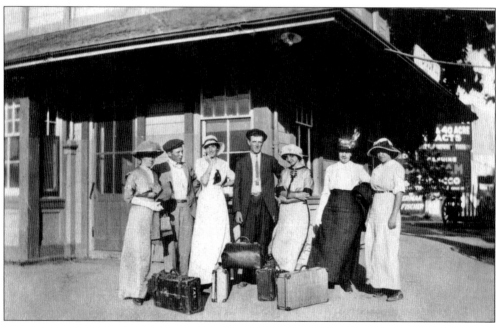

Trains carried both passengers and freight cars. Here passengers wait to board the train at the Dixon station, c. 1910.

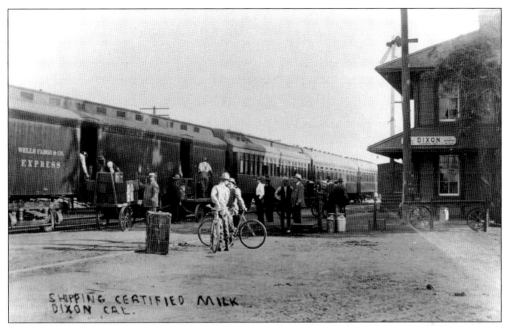

In 1972, in a move to consolidate service, Southern Pacific Railroad abandoned this station, once the hub of the community. A newly formed historical society led by district librarian Sandra Stocking and Dixon resident Jim Kilkenny tried, but failed, to raise the $12,000 needed to move and refurbish the building for use as a museum and meeting place. In this image, certified milk is loaded onto the train.

Pictured are the laborers who prepared the festivities for the dedication of the electric railroad.

OAKLAND, ANTIOCH & EASTERN RAILWAY

in connection with the

Sacramento Valley Electric Rd.

FAST ELECTRIC TRAINS

Between DIXON and

San Francisco, Oakland

Berkeley, Alameda,

Lafayette, Danville,

Walnut Creek, Concord

Bay Point, Pittsburg,

Sacramento.

Effective January 3, 1915

Leave Dixon	Ar. Dixon Junction	Arrive Pittsburg	Arrive Oakland	Ar. San Francisco	East. Ar. Sacra.
7:30 a m	8:00 a m	8:52 a m	10:02 a m	10:30 a m	
9:15 a m	9:45 a m	10:51 a m	11:43 a m	12:15 p m	10:35 a m
10:50 a m	11:20 a m	1:20 p m	2:00 p m	2:30 p m	12:15 p m
1:20 p m	1:50 p m	3:03 p m	4:02 p m	4:30 p m	2:48 p m
3:05 p m	3:35 p m	4:31 p m	5:40 p m	6:10 p m	4:25 p m
4:45 p m	5:15 p m	6:31 p m	7:22 p m	7:50 p m	6:25 p m
6:30 p m	7:00 p m				7:55 p m
7:29 p m	7:54 p m	8:41 p m	10:01 p m	10:30 p m	

Ask agent about "Comet" "Meteor" and "Sacramento Valley Limited," special thru service and observation cars.

Ask R. K. SWORD, agent S. V. E. R. R., for complete time table. Cheap week end round trip passenger rates to all points.

Direct Service to Exposition Grounds During the Fair

This train schedule, effective January 3, 1915, was for the Oakland, Antioch & Eastern Railway in connection with the Sacramento Valley Electric Railroad.

In this 1913 photo, the first electric train arrives on West A Street just east of the Southern Pacific Railroad. The station was located at the site of the current post office.

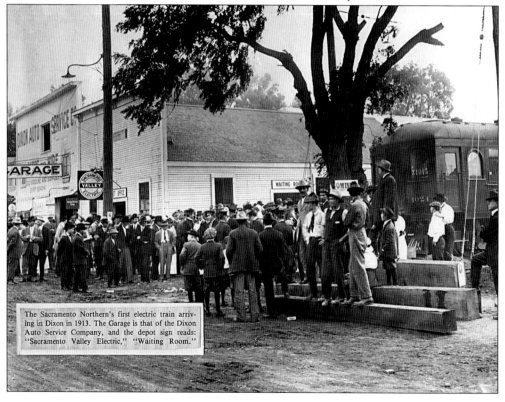

The Sacramento Northern's first electric train arriving in Dixon in 1913. The Garage is that of the Dixon Auto Service Company, and the depot sign reads: "Sacramento Valley Electric," "Waiting Room."

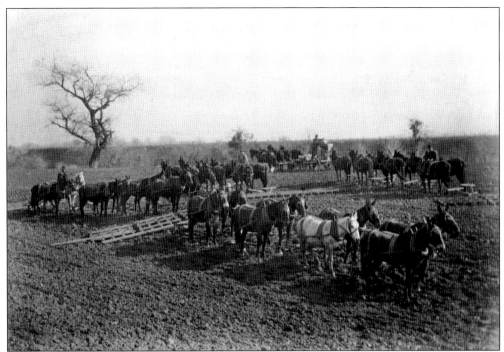

Dixon's rich agricultural heritage began in the mid-1800s with the arrival of settlers and the advent of the hydraulic pump. Irrigation water flowed through the valley, enabling Dixon farmers to grow alfalfa. Twenty to thirty mule teams pulled the plows and harrows, like the one shown above, that tilled the soil, sowed the seed, and pulled the threshers for harvest. Dixon supplied Central Valley and Bay Area with produce, lamb, swine, cattle, poultry, and dairy products. (Courtesy of Alan Schmeiser.)

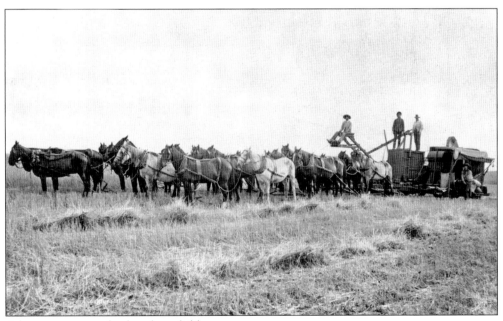

A harvest team works the wheat field.

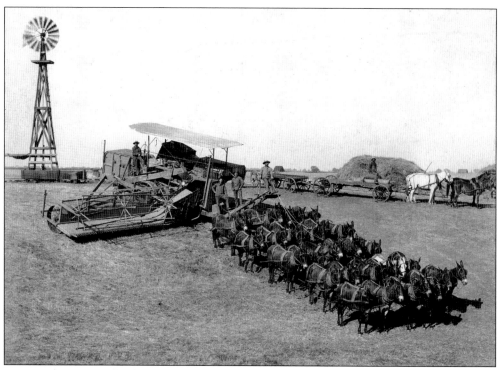

A 30-mule team pulls the grain harvester (thresher), while the wagons and mules in the background wait to haul grain sacks to mill. Note the windmill in the background. (Courtesy of Alan Schmeiser.)

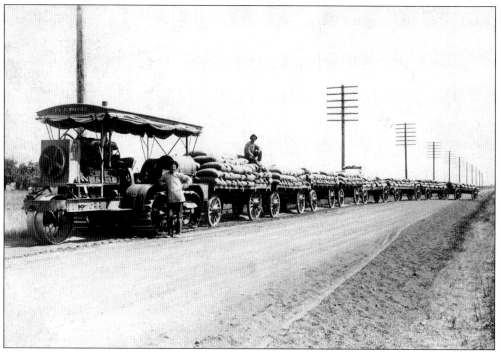

These barley sacks are going to the mill.

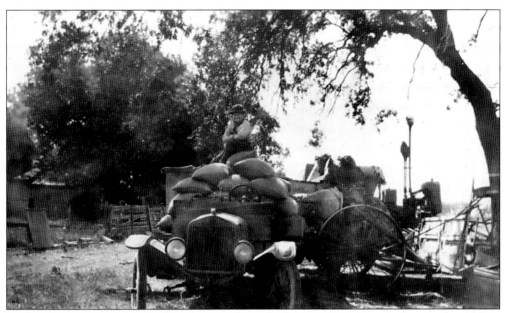

In this photo, a Model T Ford hauls grain from the Hansen Ranch to market, as the shift to automation begins.

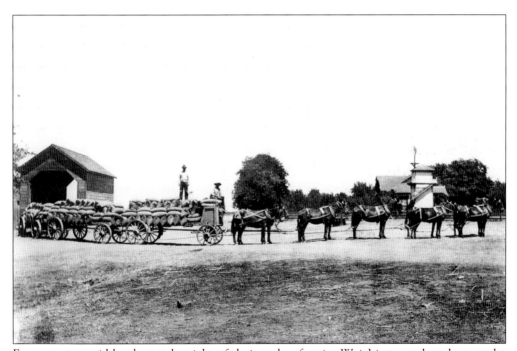

Farmers were paid by the total weight of their sacks of grain. Weighing was done here at the Batavia Weigh Station. Much haggling and many arguments took place before any money was exchanged.

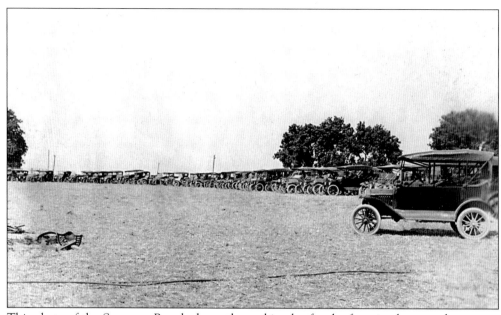

This photo of the Summers Ranch shows the parking lot for the farm implements that are on sale in the photo on the next page. Note the two rows of automobiles. (Courtesy of Phyllis Watson Houlding.)

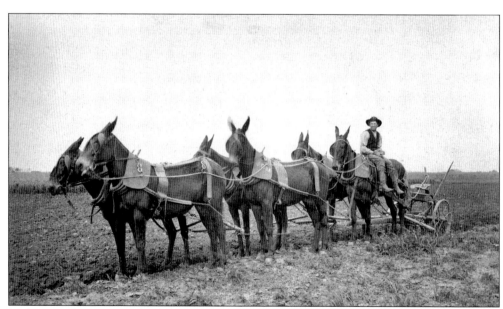

Mule team driver J. Marshall drives lead mules Madam and Mah, swing mules Star and Katy, and wheel mules Dick and Bob, c. 1884. (Courtesy of Phyllis Watson Houlding.)

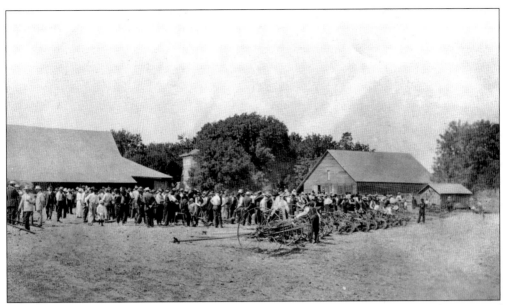

Jim Marshall's sale of farm implements took place at the Summers Ranch in 1915. (Courtesy of Phyllis Watson Houlding.)

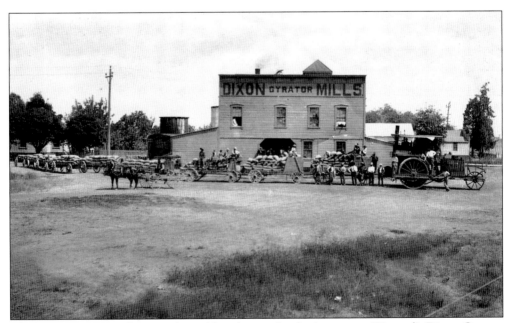

The grain was emptied into sacks and hand sewn for the journey to Weyand's Dixon Gyrator Mills for processing into flour.

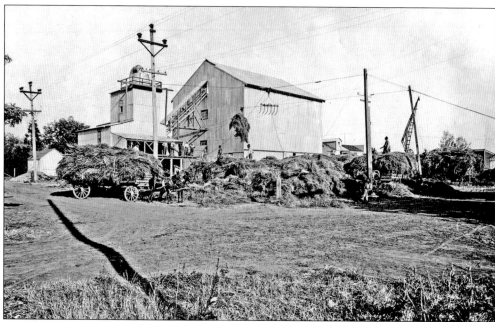

Alfalfa hay was unloaded at the California Meal-Alfalfa Company with giant hay forks operated by pulleys.

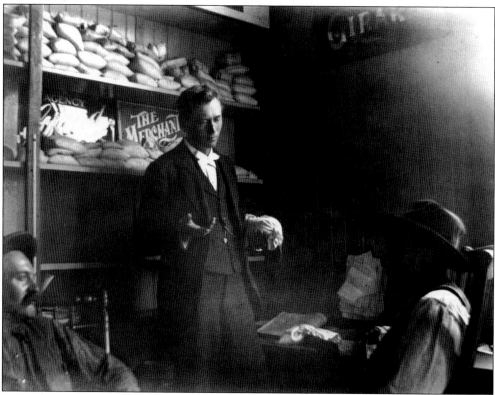

Henry R. Timm, grain buyer, is shown here at work. Notice the grain bags in the background of his office.

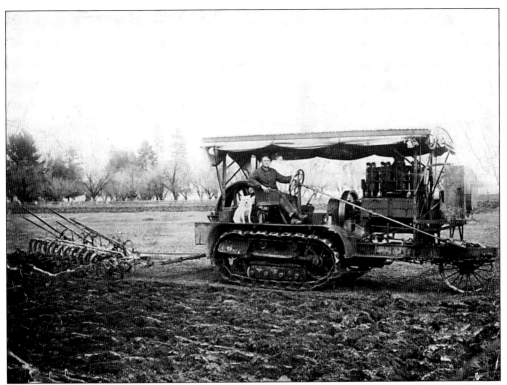

C. Smith tills the ground in preparation for planting with this 917 Holt Caterpillar Track Layer with a 65-horsepower engine.

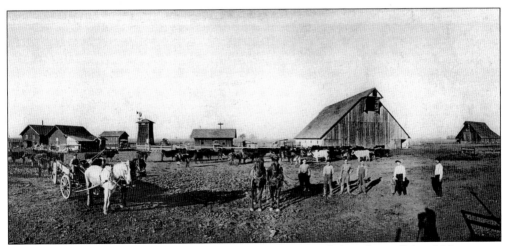

Sam Piezzi, an immigrant from Switzerland, established a small dairy farm off the old Stevenson Bridge Road around 1915. (Courtesy of Barbara Rayn Beckworth.)

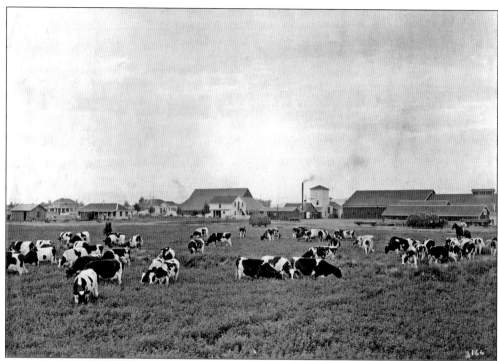

Timm Dairy cows were able to graze on alfalfa after gasoline and electric pumps began bringing in a steady supply of irrigation water. Numerous dairies were soon established as there was ample feed for the cows.

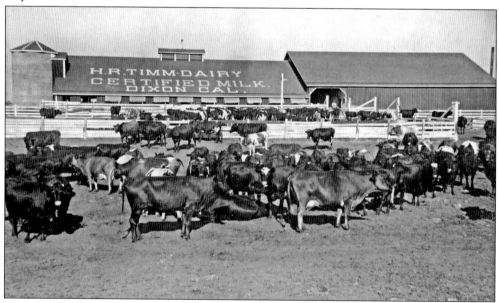

In 1909, the Henry R. Timm Dairy began raising registered Jersey and Holstein cows, which were certified free of tuberculosis. Milk was processed in an ultra-clean, sterilized environment. Workers' clothing was sterilized, cows were washed twice a day, and the milk was chilled instantly for shipping to a ready market. This dairy became one of the largest certified dairies in the United States.

Georgiana White and her cousin, Olin Timm, pose for this picture in 1917. Timm Dairy became Doyle's Certified Dairy in 1920.

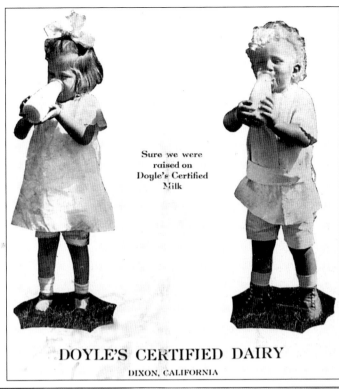

Sure we were
raised on
Doyle's Certified
Milk

DOYLE'S CERTIFIED DAIRY

DIXON, CALIFORNIA

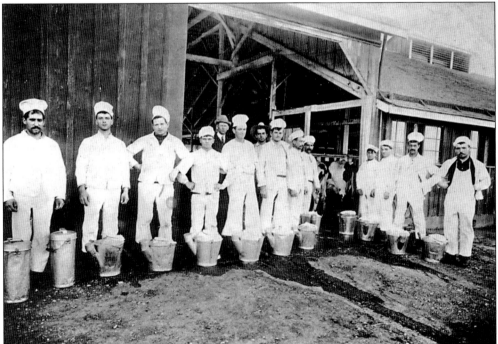

The Timm Certified Dairy, located at the north end of Doyle Lane, began operation in 1910, milking over 1,000 cows a day. Thousands of gallons of milk and cream were shipped from the "Dairy City" by rail to Sacramento and the Bay Area daily.

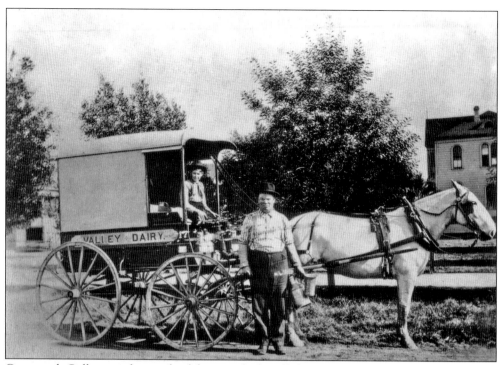

Cavanaugh Collier was famous for delivering fresh milk for Valley Dairy.

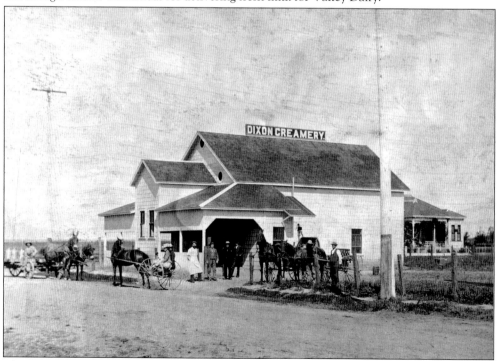

The Dixon Creamery was located on the northwest corner of Adams and West A Streets. The creamery handled large amounts of cream coming from the surrounding farms. Eventually this building became a cannery and later a Japanese laundry, c. 1890. (Courtesy of Alan Schmeiser.)

Mrs. Mary Rowe was kept busy with daily farm chores including feeding the chickens. Most families were self-sufficient and raised their own meat, such as poultry, pork, and beef, and had a milk cow or two while almost everyone had a large vegetable garden.

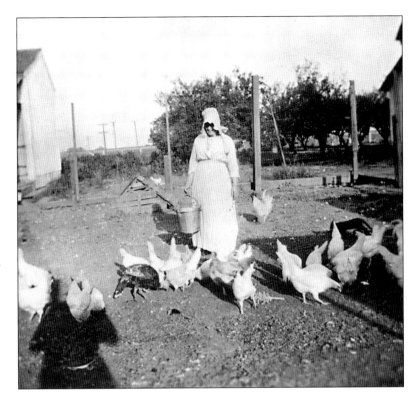

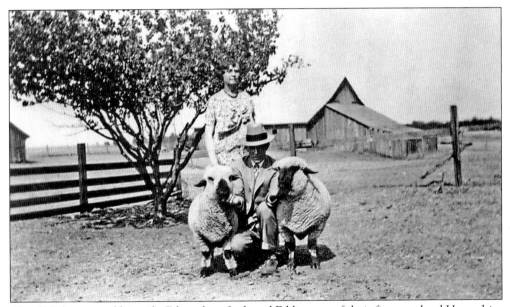

Alex F. Johnson and his wife, Edna, show Jack and Eddie, two of their fine purebred Hampshire sheep. Alex, who died in 1937, was highly respected in Solano County as a breeder of purebred sheep. (Courtesy of Lucy Vassar.)

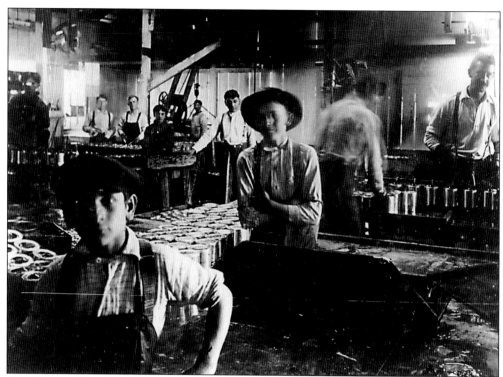

Young boys found summer jobs working in this unidentified Dixon cannery. (This was before child labor laws were enacted.)

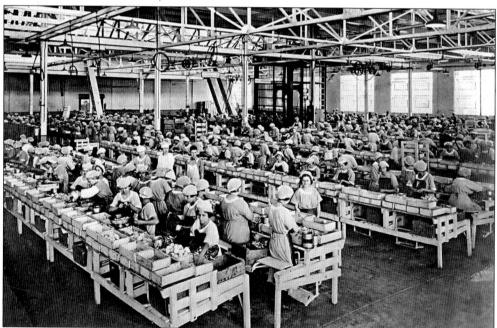

With water readily available, many fruit and nut orchards were planted and the two canneries had a large workforce of mainly women. One cannery was located on West Broadway and the other was housed by the railroad tracks on Adams and West A Streets.

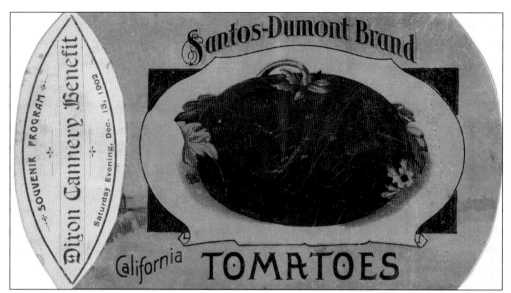

The Dixon Cannery Benefit was held on December 13, 1902. The Santos-Dumont Brand Tomatoes can label was handed out as a program.

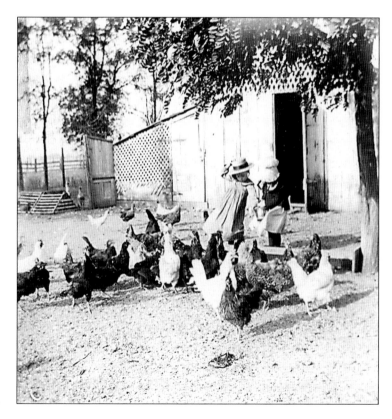

These unidentified children had the responsibility of feeding their homegrown chickens.

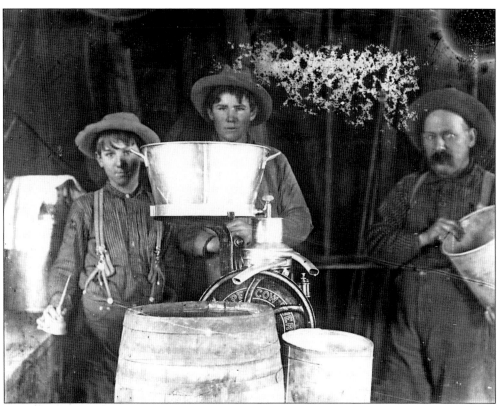

Milk separators were used by local farmers to separate the cream from milk.

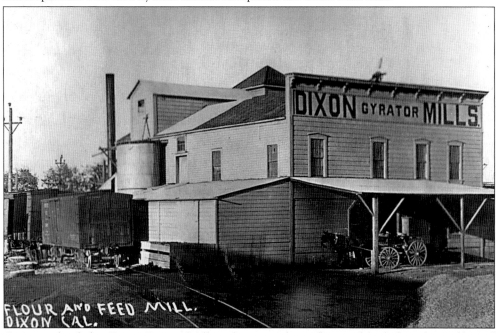

Grain was hauled to Dixon Gyrator Mills and processed into flour and feed, then shipped by rail to its final destination.

Two

AROUND TOWN

If you were to stroll through downtown Dixon in 1884, you would have found a community that had an opera house and six hotels: the Arcade, Empire, King, Palace, Capitol, and the Centennial. You would barely have noticed the effects of the devastating fire of November 1883, when nearly the entire town had to be rebuilt. Merchants hardly took a breath before the new brick structures were erected so that business could continue. Granted, not much had been done to improve the muddy, lumpy streets, but the boardwalks and awnings were back and merchandise was reappearing in the stores. Then came the April 1892 earthquake, which was almost as disastrous as the fire. Undaunted, merchants rebuilt, rearranged, reinforced, and opened for business once more.

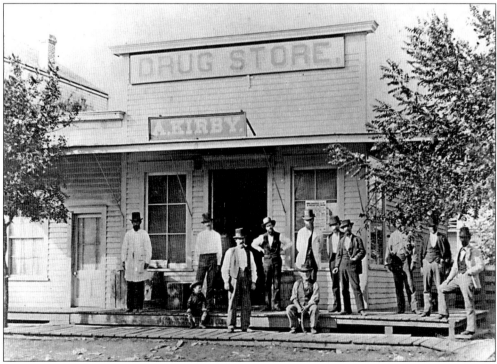

Kirby's Drug Store, the first drugstore in town, was one of the buildings moved from Silveyville in 1870. Located on the southwest corner of First and A Streets, it was destroyed by the 1883 fire. Shown here, from left to right, are Constable T.B. Barnes, professional gambler Sam Brown, farmer T.B. Buckles, and A. Kirby; (seated) ? Holverstat, Louis Duprey, Charles Newman, farmer George Barlow, unidentified, and Mr. Bloom, father of John Bloom.

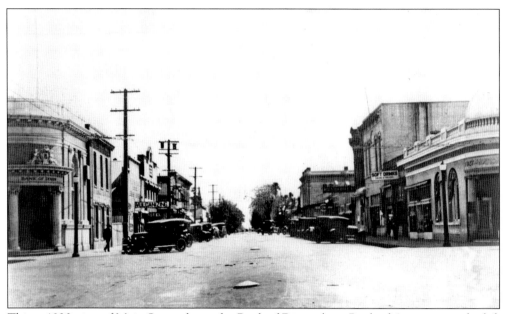

This *c.* 1920 view of Main Street shows the Bank of Dixon, later Bank of America, on the left corner and the First National Bank on the right corner.

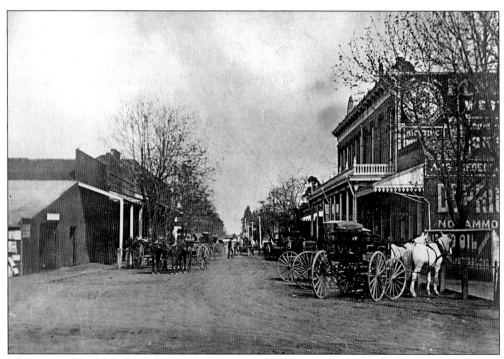

This view of B and Jackson Streets looks east with the opera house on the right and Schulze's Department Store on the left.

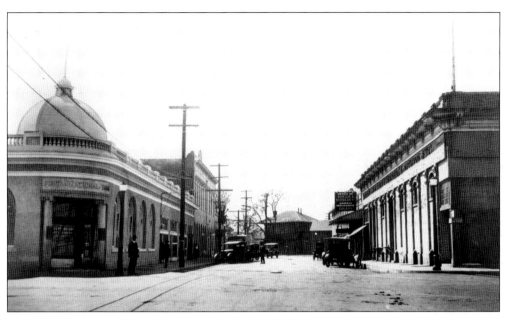

Schulze's General Mercantile is on the right corner and the First National Bank is on the left in this c. 1915 view of West B Street looking toward the railroad station. Just 20 days after the bank opened in 1910, it had 93 accounts with deposits totaling $75,305. After four months in business, the depository numbered 180 accounts totaling $101,649. (Courtesy of Ardeth Sievers Riedel.)

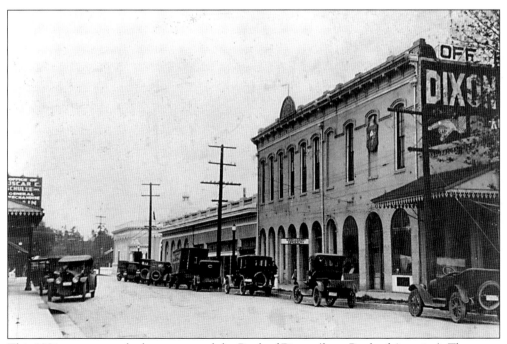

This 1921 street scene looks east toward the Bank of Dixon (later Bank of America). The opera house is located on the right above the grocery store.

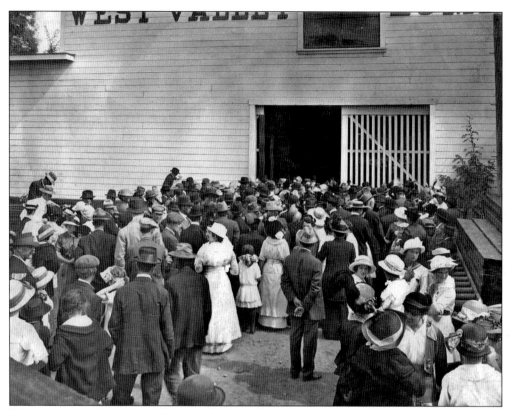

This auction at the West Valley Lumber in Dixon took place in 1913. Those were the days when both men and women wore hats, and the skirts touched the ground.

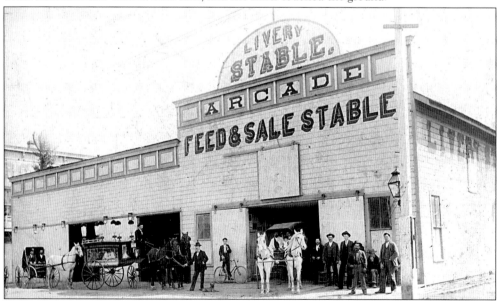

Before gas stations and automobiles, towns had livery stables to tend to the horses belonging to both the residents and people traveling through town. This livery stable was next to the Arcade Hotel, which was located where the A Street Deli and Frosty are today. (Courtesy of Alan Schmeiser.)

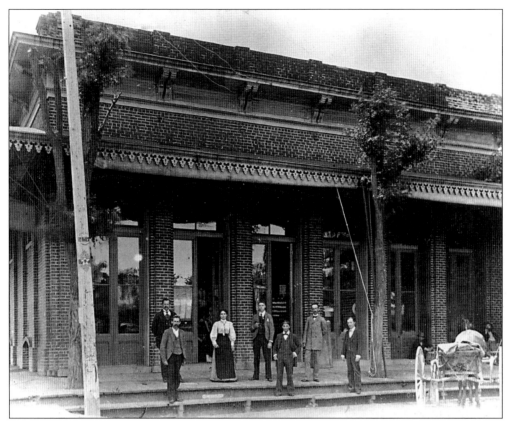

Eppinger's General Merchandise, located on the northwest corner of First and B Streets, was one of the largest mercantile businesses in Northern California. The business grew to the point that it served as a bank for many Dixonites. In 1880, Eppinger rebuilt his store in brick, thus sparing it from the devastating flames of the 1883 fire.

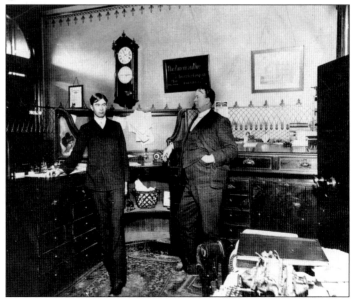

Bank of Dixon president John Rice is shown here with his son Scott. This bank eventually became Bank of America.

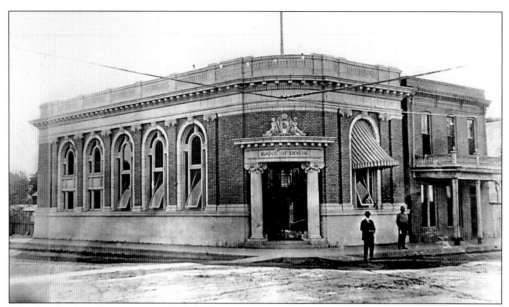

The first bank in Dixon was called the Bank of Dixon and was located on First and B Streets.

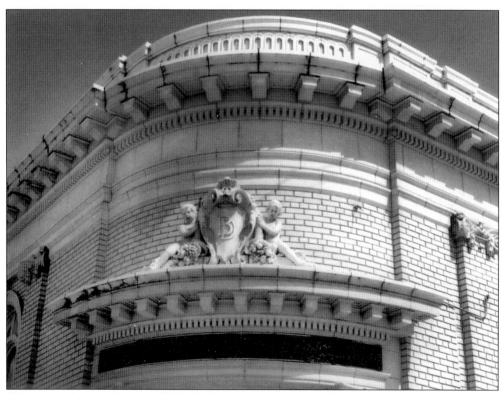

This image shows architectural details above the entrance to the Bank of Dixon. (Courtesy of Harold Axelson.)

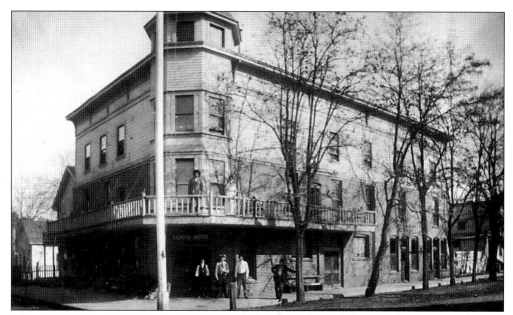

The Capitol Hotel stood on the southeast corner of First and A Streets. The original hotel on this site was the City Hotel, built in 1876 and owned by the Frahm Brothers. In 1885 Mrs. Morris bought the building and tore it down to build the Vendome, which became known as the Capitol Hotel. Mrs. Morris met and married a San Francisco man only to discover that he was a bigamist. The Capitol eventually ended up in the hands of the Dawson brothers, who owned it at the time it burned to the ground in 1920. This photo was taken *c.* 1918.

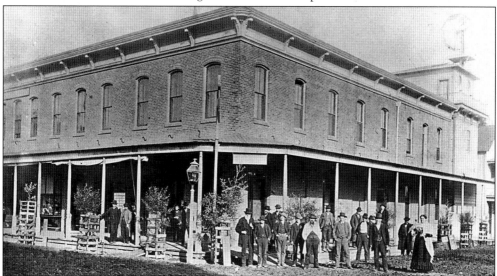

The Palace Hotel, located on the northeast corner of First and A Streets, was built of brick and so survived the 1883 fire. It was built in 1876 by William Johnson, who purchased the Blum & Son's building in Silveyville and brought the bricks to Dixon to construct this hotel, which may be the oldest existing brick building in Dixon. Here, Judge Miner (with long beard at center) stands near the lamp post. Mr. Wagner is the barber in the white coat and, on the far right, hotel owner Richard Hall stands next to his wife, Mrs. Patterson Hall. Behind her is Newton Buckles with John Madden (in the long overcoat) to his left, *c.* 1879.

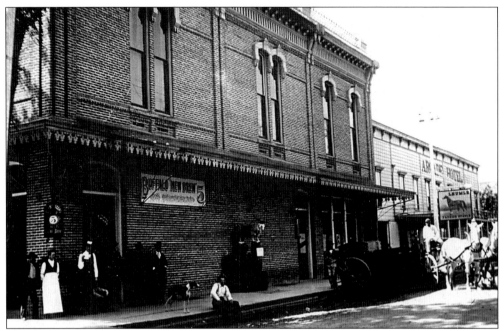

This *c.* 1895 image shows the IOOF (International Order of Odd Fellows) building after the big fire. This shows a saloon with the Arcade Hotel and Fashion Stables to the rear, L. Kumle, proprietor. Note the greyhound on the boardwalk. Dog races as well as horse races were popular in the 1890s.

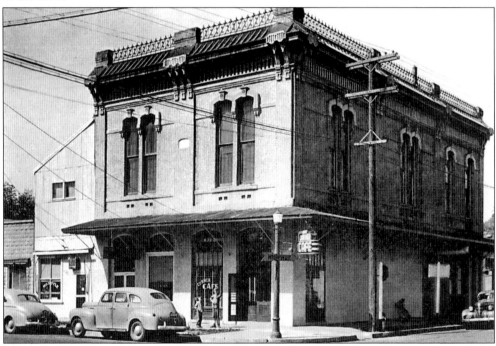

This view of the IOOF building was taken in 1950. The Corner Cafe (now Bud's) was founded by Tom Wong in 1944. To the left was the Dixon Home Bakery, Siefert family proprietors. The *Dixon Tribune* office was located on the far left.

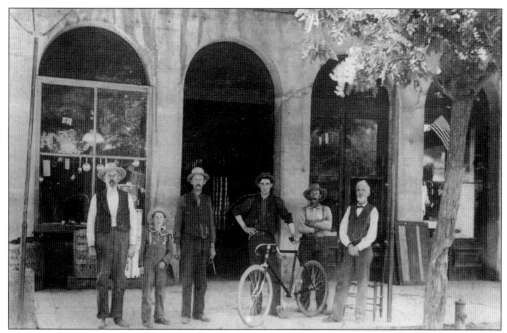

J.D. Johnson's Hardware Store stood on the northwest corner of First and A Streets and was originally built by William R. Ferguson at the founding of Dixon in 1868. After the 1883 fire destroyed the building, William Johnson bought Blum & Son's brick store in Silveyville and used the bricks to construct the new hardware store. W.R. Ferguson died in 1896, and the store was purchased by Cowden & Clausen. J.D. Johnson, pictured far right, became the owner in 1898. Joe Dawson bought the building in 1943, and it has been called Dawson's ever since.

One of many William Van Sant's inventions, the Nickel Soda Machine, is shown here c. 1895. A notable inventor and entrepreneur, Van Sant invented an egg tester, an ingenious chart for teaching beginners how to find different chords on the piano, a device for cleaning oranges, lemons, apples, and other fruit, an electrical drinking fountain, a peanut roasting machine, and a musical instrument called a panderina.

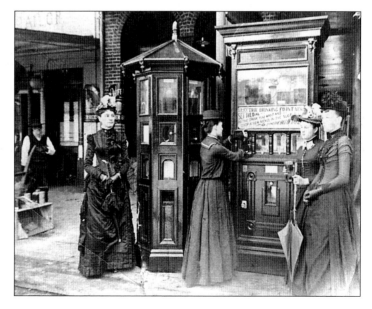

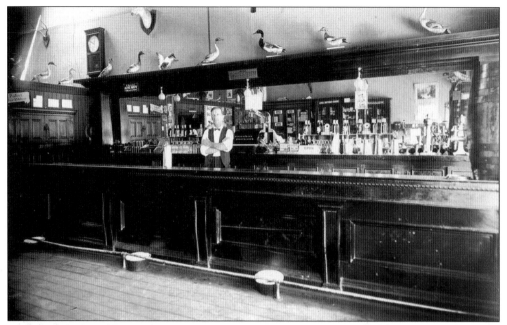

A 1930s bar owned by George Amiel Peters Sr. was located on First Street close to Dawson's and later became Kim & Ned's. (Courtesy of Wes and Joanne Jacobs.)

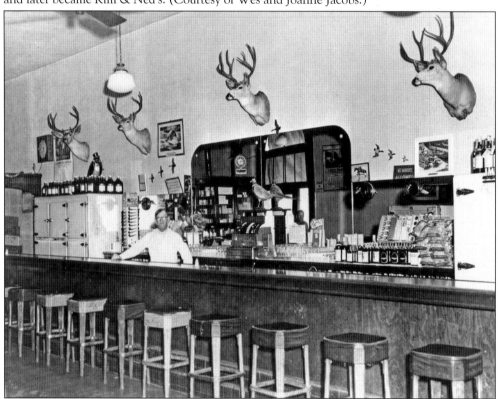

Tom Desmond tends bar at Dawson's, which first opened June 1, 1944, on North First and A Streets. Dawson's building was originally established in 1908.

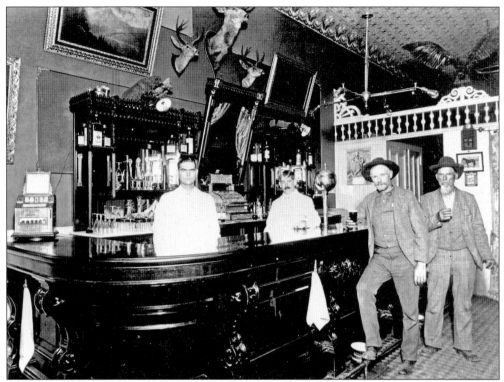

The GEM Saloon closed during Prohibition in the 1920s. W. "Bill" Milligan bought the site in 1930 and converted it into the GEM Drug Store. When the sidewalk was rebuilt, the brass GEM letters were preserved and can be seen today where the saloon was originally located.

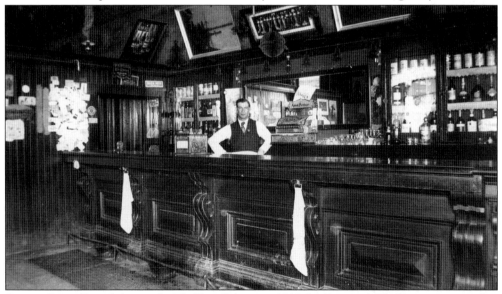

Stormy Connell tends bar at the Fly Trap Saloon, c. 1910. McDermott's Fly Trap was reputed to have a rowdy clientele who, after much drinking, would get in the watering trough where they'd float for a while before going back into the bar. By the end of the evening, the Fly Trap was waterlogged. Today, this bar is a coffee house on the corner of West A and North Jackson Streets.

Van Sant Grocery Store, shown here c. 1920, was located two doors south of the GEM Saloon and below the Masonic Hall. Van Sant & Brothers was an enterprising firm whose three traveling wagons visited almost every farmhouse in upper Solano, Yolo, Colusa and Tehama Counties in preparation for their "trade indoors" rather than traveling door-to-door. They bought for cash and sold for the ready coin. In 1903 William Van Sant installed an elevator at the rear of his store—the first in Dixon. (Courtesy of Ardeth Sievers Riedel.)

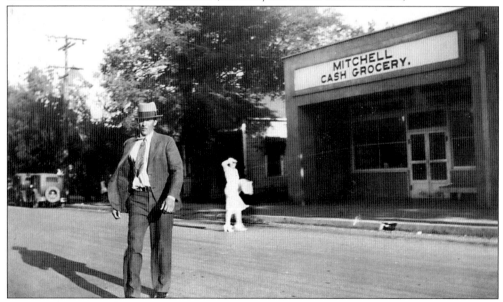

Mr. Mitchell crosses East A near First Street at the site of Mitchell's Cash and Carry Market, which later became Pardi's Market. (Courtesy of Ardeth Sievers Riedel.)

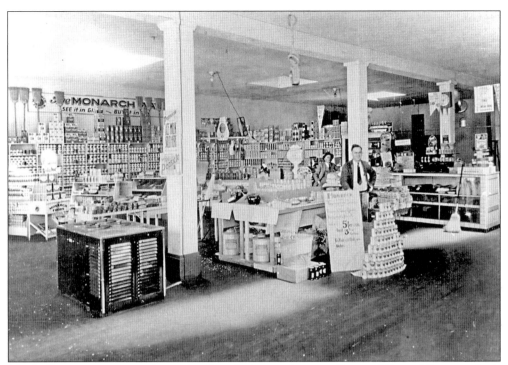

Mitchell's grocery store was located at East A Avenue between First and Second Streets, which later became Pardi's Market. The community identified with Mitchell's and referred to it as "our store." Mitchell's offered home delivery with the large truck van seen below.

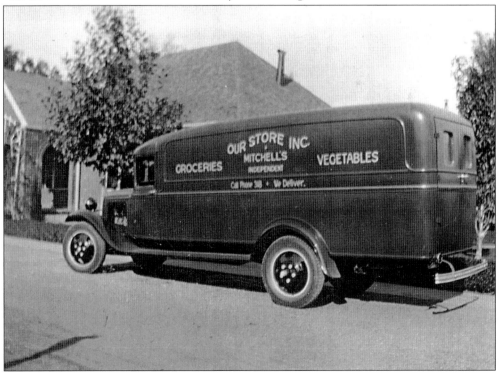

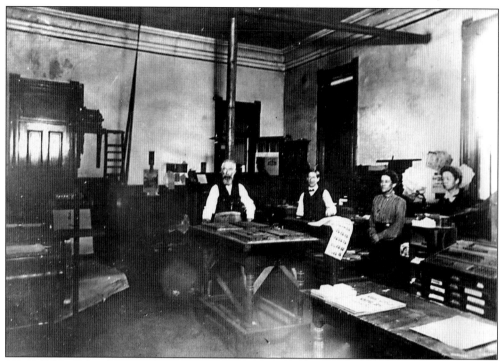

Dixon Tribune editor and publisher Rowland Moss sits at the desk in the editorial office, *c.* 1925. The *Dixon Tribune* was established in 1874.

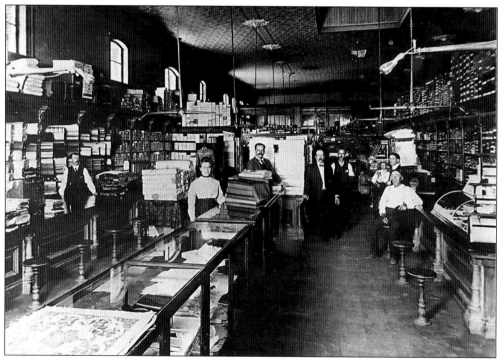

Oscar Schulze's General Store was purchased by Stuart Grady in 1925. Shown, from left to right, are Phoebe Collier and Oscar Schulze with Eugene Ferguson fourth from left.

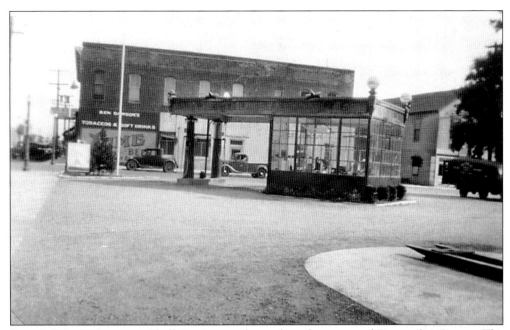

Francis "Tige" Thomsen's Shell Station was located on the corner of First and A Streets. The Palace Hotel can be seen behind the station. Shown below is Tige Thomsen at his new station, c. 1936. (Courtesy of Greta Thomsen.)

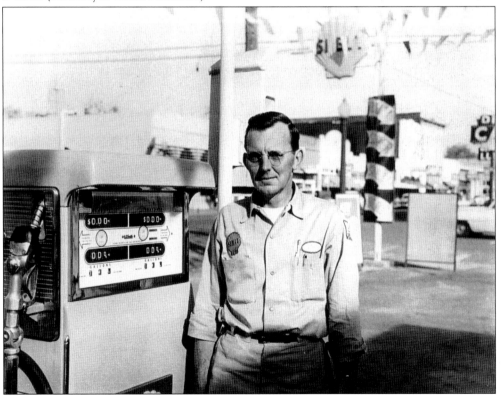

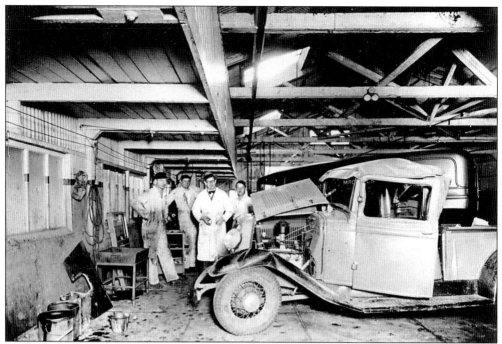

John Thompson assesses a damaged pickup in an auto repair garage.

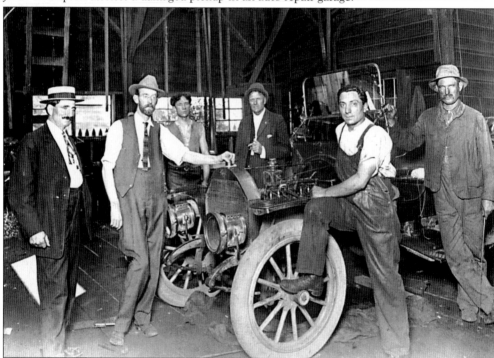

Milton Carpenter II opened a blacksmith shop and livery stable on North First Street in 1911. It soon added a car repair and dealership, owned by Emil Rossi. The blacksmith and stable continued to be owned solely by Milton Carpenter, who also ran a mortuary at the same location. (Courtesy of Bud Rossi.)

A 1930s *Dixon Tribune* advertisement calls attention to the Rossi Brothers's Garage. (Courtesy of Bud Rossi.)

In 1912, Emil Rossi and Clarence Frese formed a partnership to repair and sell automobiles. Located at South First and C Streets, the Dairy City Garage prospered. In 1915, when Clarence Frese left to go into the army, Henry Rossi purchased his share of the company and became partners with Emil. The company name was then changed to Rossi Brothers. (Courtesy of Bud Rossi.)

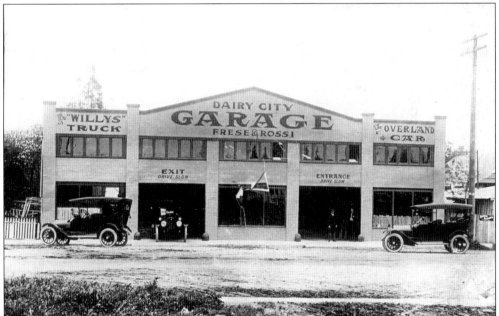

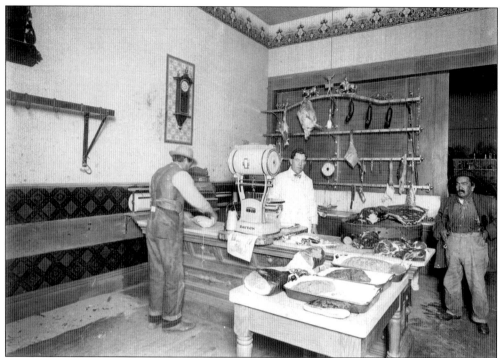

Henry W. Timm owned this butcher shop. He was the cousin of Henry R. Timm, first president of Northern Solano Bank. (Courtesy of Alan Schmeiser.)

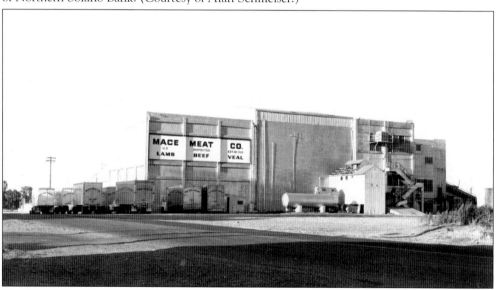

The Mace Meat Packing Plant was the first large slaughterhouse in Dixon, built by C. Bruce Mace in 1919 after he bought the former Hutton Dairy property along North First Street. His brothers, Alden (Slim) and Cal, soon joined him in the business. In the early years, they slaughtered five or six cattle and 20 sheep a day. The business continued to expand so that by the late 1940s the plant was processing 2,000 lambs and 200 cattle daily. The company was sold to Armour Meat Company in 1958. The facility was eventually sold again and in the 1980s was closed and subsequently demolished.

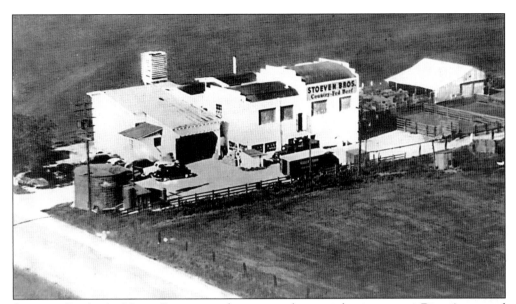

Stoeven Brother's Meat Company, shown in this aerial view, was Dixon's second slaughterhouse. Built by George F. Livingston, it was located south of town on the Rio Vista Highway, but did not prosper. In the 1930s, Livingston sold the business to Willie and Danny Marks. The plant soon expanded and was sold two more times before 1949, when the Stoeven brothers, Lawrence, Hal, and Chet, bought the plant. Their children, Larry, Bob, and Gladys, along with her husband, Ross Hanna, rebuilt the aging plant. Today the plant is operated by Superior Meat Company and is the largest lamb slaughterhouse in California.

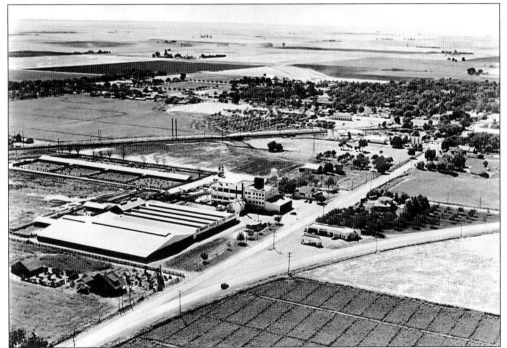

This aerial view of the Mace Meat Plant was taken in the 1940s. The picture shows the intersection of North First and North Adams Streets. (Courtesy of Ardeth Sievers Riedel.)

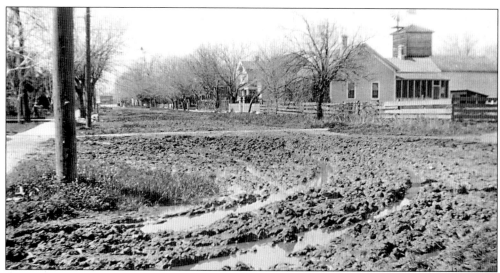

This muddy street was outside the area where the original Dixon High School gymnasium stood on Fourth and B Street. If you look down the street, you can see the train depot in the distance. Muddy roads were a constant challenge for farmers and travelers alike for many months of the year.

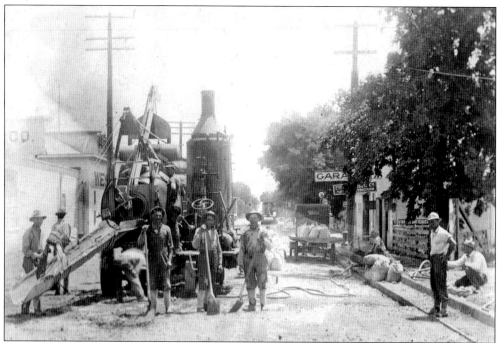

Workers pour concrete for the new road surface for Old Highway 40 on West A Street by West Valley Lumber Company in 1911. About this time, 12-foot-deep sewer lines were also being constructed. One evening during the construction, Henry Glide was driving a team and leading a mule behind when he attempted to cross the ditch via a makeshift bridge, but the mule balked and fell into the ditch headfirst. A lady attempting to cross the ditch fell in on top of the mule. Just after her rescue, a laborer came running up and fell in, then his friend tumbled in on top of them all. Everyone was ultimately rescued, including the mule.

Three
SPECIAL EVENTS

Parades in Dixon were popular events with highly decorated floats, cars, horses, and of course, marching bands. The May Day celebration and parade have been the highlight of the town's year since 1876. The Knights of Pythias were responsible for the original preparations of the May Day activities, which included the selection of a queen of the May, a maypole dance, picnic, and most importantly, a parade. The annual Independence Day Parade, picnic, and festivities were also always well attended. Today Dixon is still known for its May Fair celebration, and each year attendance increases.

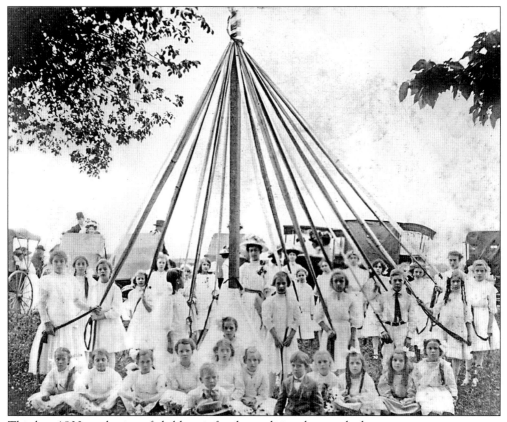

This late 1800s gathering of children is for the traditional maypole dance.

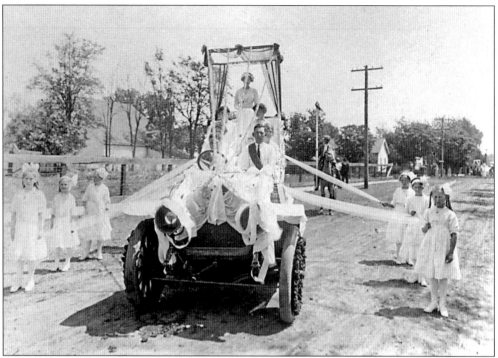

Eva Field, the May queen, rides the May Day queen's float on May 3, 1913.

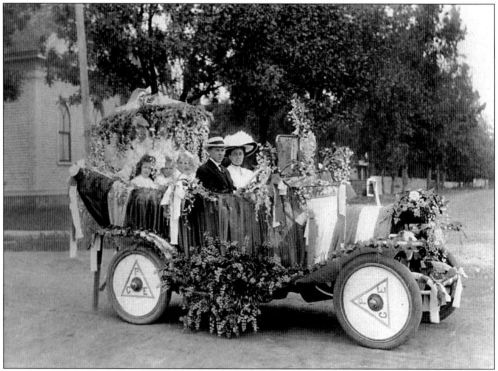

In May 1911, PG&E employee Charlie Sedgwick, with his wife Kate Sedgwick and their children, paraded through Dixon.

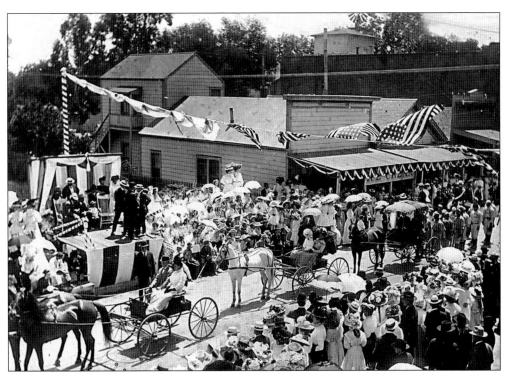

The 1908 May Day parade heads north on First Street.

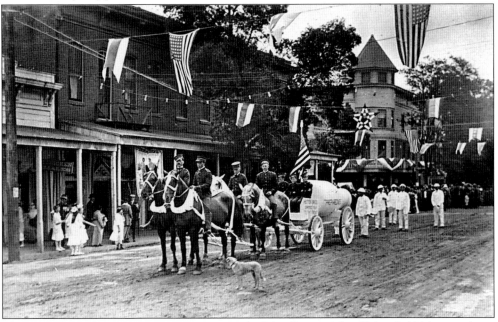

The Hutton Brothers Dairy's unique entry in the May Day parade of May 6, 1916, was a huge milk bottle made to look like a Howitzer cannon mounted on heavy wheels. The theme was "Preparedness," a World War I political topic of the day. The entry's "artillery boxes" contained bottles of certified milk placed to resemble shells. Dixon's leading hotel, the turreted Capitol in the background, burned to the ground in 1920.

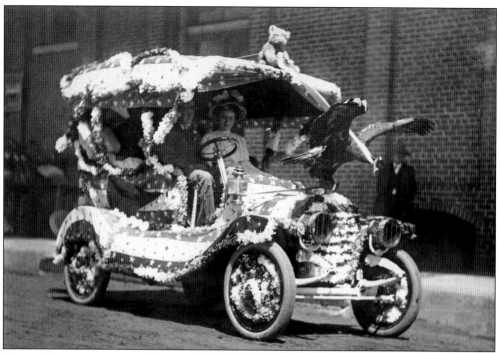

The teddy bear car in this 1904 May Day parade also featured an American eagle in honor of President Theodore Roosevelt.

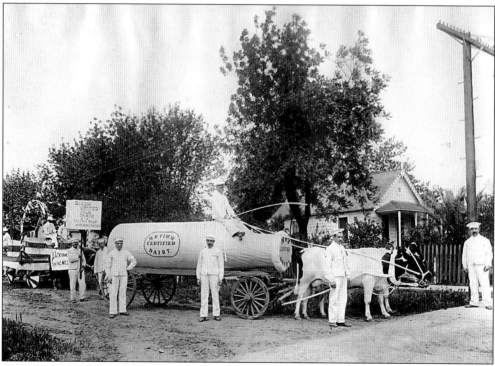

The Timm Dairy float, carrying a giant milk bottle, was drawn by cows during the May Day parade. (Courtesy of Alan Schmeiser.)

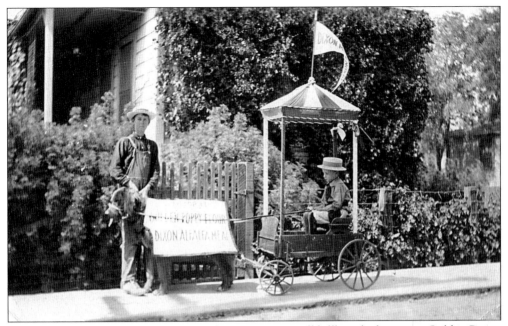

This *c.* 1910 May Day parade entry is a dog carrying a small billboard advertising Golden Poppy Flour and Dixon Alfalfa Meal.

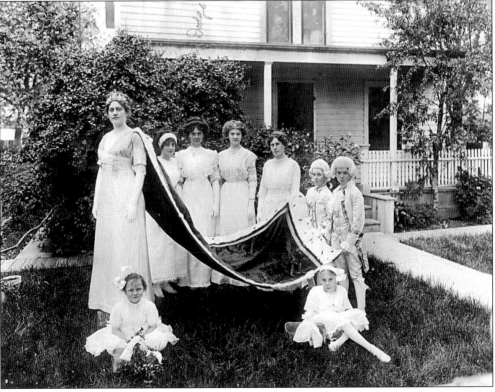

The May Day queen appears with her court, including young male attendants wearing Colonial-style, white powdered wigs and French court attire. (Courtesy of Alan Schmeiser.)

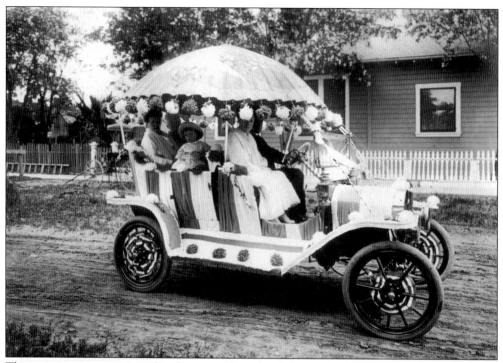

This unique entry participated in the annual Fourth of July parade. (Courtesy of Alan Schmeiser.)

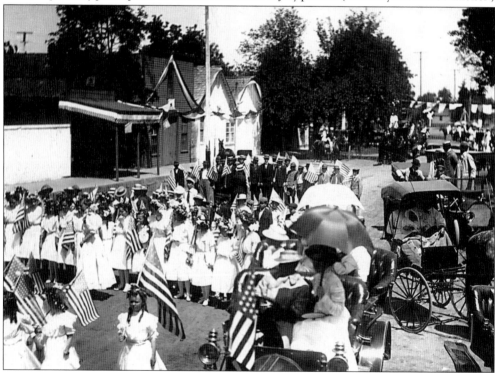

It was a patriotic act for people of this generation, as it is today, to hold a Fourth of July parade. It was always a well-attended celebration, as evidenced by this *c.* 1910 photograph.

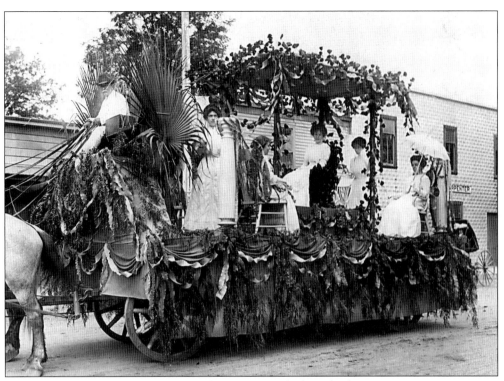

The May queen's float passes in front of Carpenter's Blacksmith Shop, *c.* 1910.

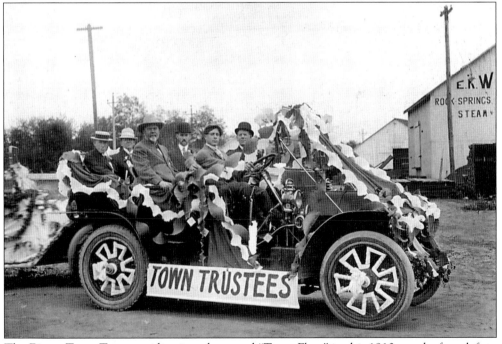

The Dixon Town Trustees riding in a decorated "Texas Flyer" in this 1910 parade, from left to right, are (front seat) driver Louie McDermott and Jack Kerr, president of the board; (middle seat) John McDermott and Milt Carpenter; (rear seat) Rowland Moss and Bill Weyand.

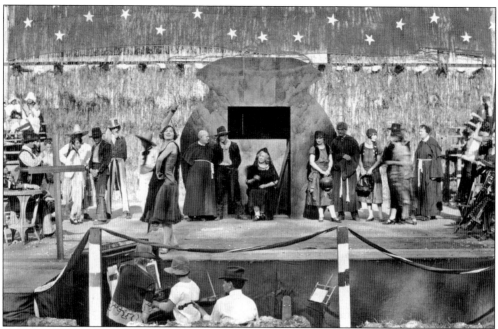

This Melting Pot Celebration took place after the 1925 May Day parade, where representatives from each nationality performed a skit, song or some other form of entertainment representing their culture. A seven-year-old Bud Rossi watched this pageant and remembers a man in an Arabian costume rescuing an "injured" woman by riding by on his horse and whisking her from the stage.

DIXON THEATRE
DIXON, CALIFORNIA

SUNDAY, MONDAY, TUESDAY, JAN. 11, 12, 13

NORMA TALMADGE
in Sam Taylor's production
"Du Barry Woman of Passion"
With Conrad Nagel and William Farnum

Norman Talmadge soars to the highest peaks of artistry as "Du Barry" the Enchantress who almost looses an honest love when she falls into a trap baited with luxury, ease, and precious jewels.

Adults 50 cents Children 15 cents

This *Dixon Tribune* ad was for the Dixon Theatre, *c.* 1930. (Courtesy of Grace O'Neill.)

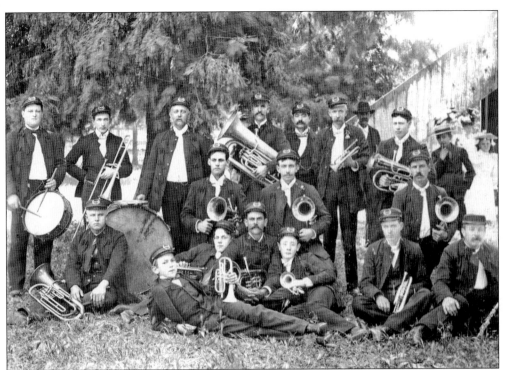

Dixon's first band was formed in 1898 by B.F. Newby, shown standing third from the left. Newby played the E-flat tuba and sometimes the bass drum.

The two Moy Brothers seated here were friends of B.F. Newby. They were in the furniture business.

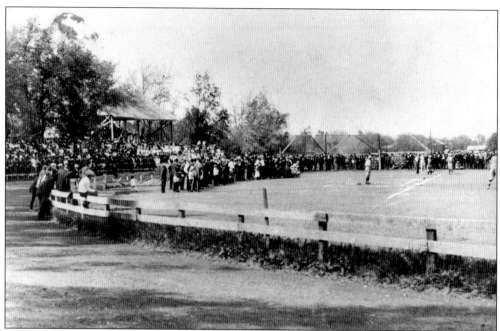

In 1885, the Dixon Driving Park Association was formed for the specific purpose of racing area trotters. The Dixon Race Track was built and maintained on the present site of the May Fair grounds. The most popular time for races was during the May Day Celebration when some of the best trotters and pacers in the state came to Dixon. The track was used year round. Baseball games and athletic events were played inside the track area. (Courtesy of Ardeth Sievers Riedel.)

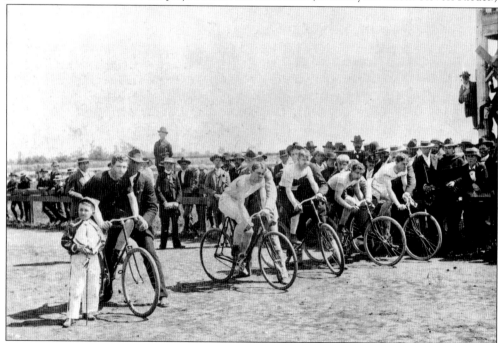

In 1895, bicycle racing became a sport of interest. Dixon held races on the fairground tracks through 1910 using the same track as the trotters. (Courtesy of Ardeth Sievers Riedel.)

Veterinarian Dave Herspring of Woodland and his horse are prepared for the great race at the May Day Celebration. (Courtesy of Ardeth Sievers Riedel.)

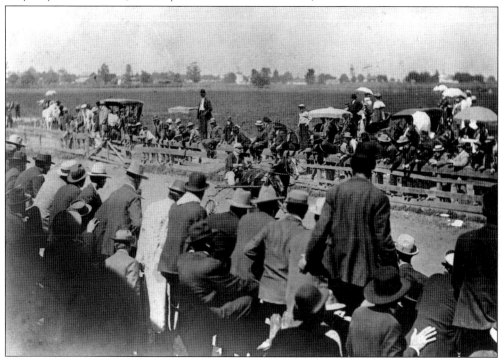

These trotter races were held at the fairgrounds during the May Fair Celebration around 1890. The area in the background is where the little league fields are currently located. (Courtesy of Ardeth Sievers Riedel.)

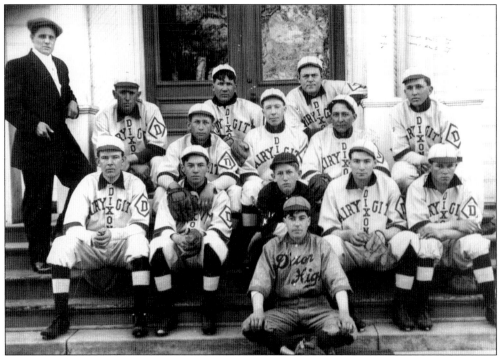

Next to horse and bicycle racing, baseball was the favorite sport in Dixon. In fact, baseball games were held eight months out of the year. Intercity league competition was fierce. In the late 1880s and early 1990s, Dixon had many outstanding athletes who brought fame to the town. Among them were sons from the Rohwer and the Van Sant families who played local and league baseball on dirt fields and traveled to the games by horse-drawn buggies. The 1916 Dixon Dairy City Team, from left to right, are (center front) Tommy Ward; (front row) Cecil Ferguson, Hermon Fischer, Claude Rohwer, Vern Lewis, and Lowell Eames; (middle row) Roy Rohwer, Angus Madden, Merle Valdez, and Eggert Rohwer; (back row) team manager Leonard Ferguson, Hans Rohwer, ? Myers, and Clay Grove.

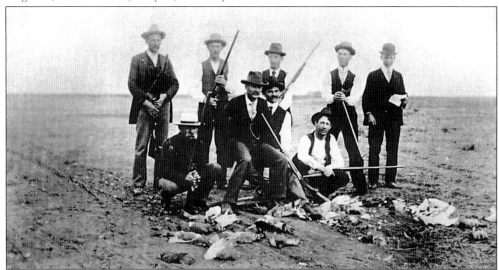

In 1900, a group of well-dressed hunters participate in a pigeon hunt.

Four
PUBLIC SERVICES

The Dixon Fire Company was organized on October 15, 1871, four years after the town was moved from Silveyville. Known as the Dixon Hook and Ladder Company, its first fire-fighting equipment consisted of a hand-drawn truck that carried ladders, hooks, and buckets. The truck was housed in a garage on a lot which is now known as the Dixon Women's Improvement Club Park. The first fire station was built in 1891 on Jackson Street. The second station was built in 1929 and served the community until 1998, when a new state-of-the-art station was built on Ford Way off North First Street.

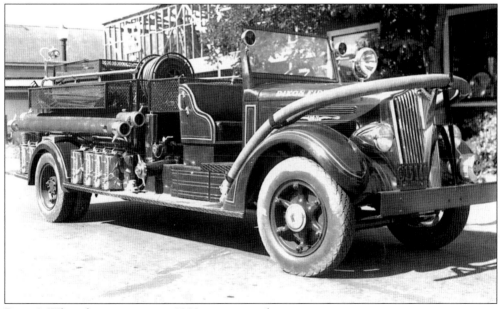

Dixon's White fire engine was a 1932 pumper truck.

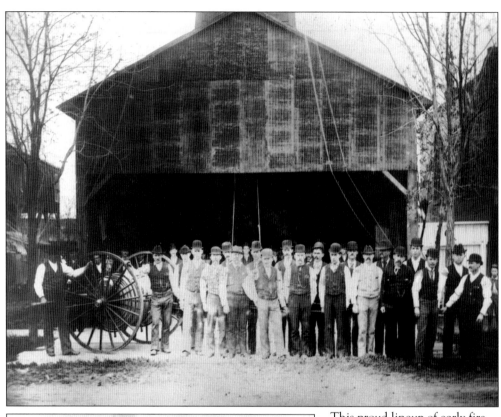

This proud lineup of early fire company volunteers with the hose cart was photographed in front of the fire department, c. 1898. (Courtesy of Ardeth Sievers Riedel.)

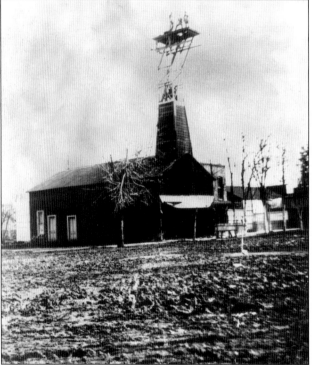

Dixon's first fire station was built in 1891 on Jackson Street between West A and B Streets. Note the alarm bell on top of the tower. This bell sits today in front of the current fire department. (Courtesy of Ardeth Sievers Riedel.)

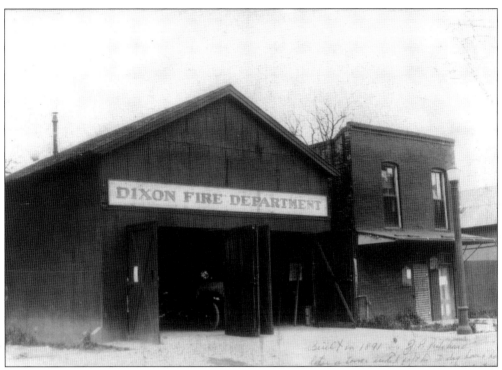

The Dixon Fire Department station and jail, shown here c. 1921, were built in 1891 on Jackson Street. (Courtesy of Ardeth Sievers Riedel.)

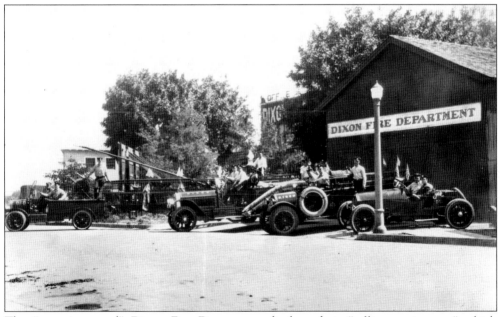

The "new, improved" Dixon Fire Department displays their "rolling equipment," which included a 1921 La France pumper truck, shown second from the left. The truck has been restored and is a favorite during the May Fair parades. (Courtesy of Ardeth Sievers Riedel.)

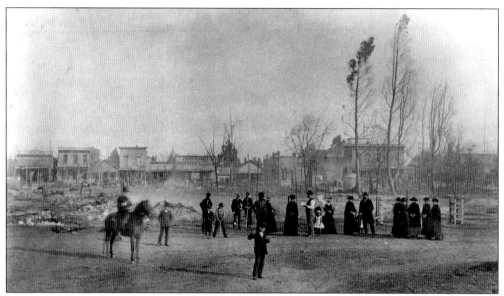

The disastrous fire of November 19, 1883 started in the kitchen of the Centennial Hotel on the corner of West B and Jackson Streets. Due to strong winds, the fire was soon out of control, and the downtown area on the west side of Main Street was destroyed within an hour. This photo shows a group of people standing on Jackson Street near the railroad tracks. After the fire devastated most of the businesses and some homes, Dixon's town trustees passed an ordinance stating that no wooden structures could be built in the downtown area. Consequently most of the buildings were constructed of brick while a few others were built of corrugated metal. Some of these brick buildings are still in use today.

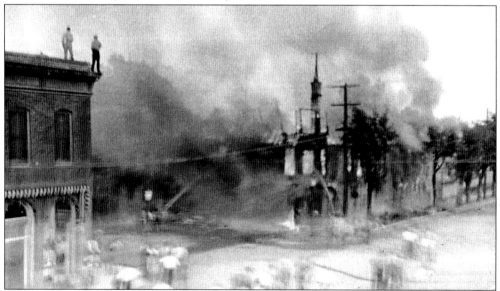

The Capitol Hotel at First and A Streets caught fire in 1920. The fire was fought unsuccessfully by the local fire department with its two hand-drawn hose carts. Eventually the Vacaville Fire Department arrived with a motorized fire engine to extinguish the fire. Regrettably, fire fighter Joe Probst lost his life when he fell from the ledge of the Palace Hotel. (Courtesy of Dixon Fire Department.)

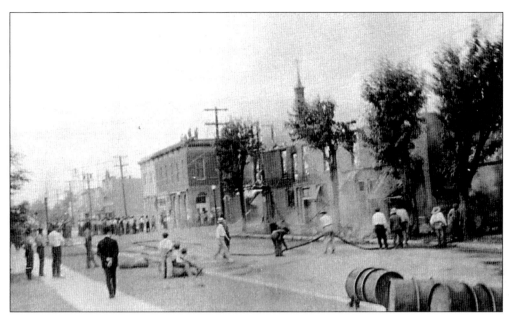

Due to this catastrophic fire, the people of Dixon decided to purchase their first fire truck, and citizens raised $10,000 for the new engine. The American La France fire engine arrived in July 1921. With the purchase of the motorized pumper, the fire department could now serve rural areas. (Courtesy of Dixon Fire Department.)

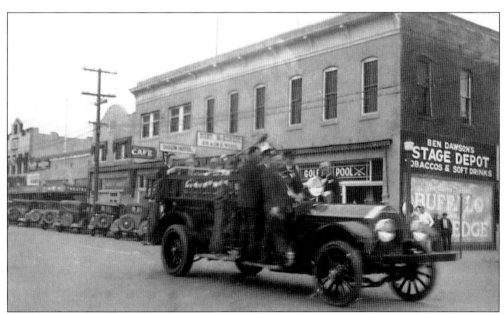

The La France engine rushes to a fire. Note Ben Dawson's Stage Depot on the east side of First Street. (Courtesy of Dixon Fire Department.)

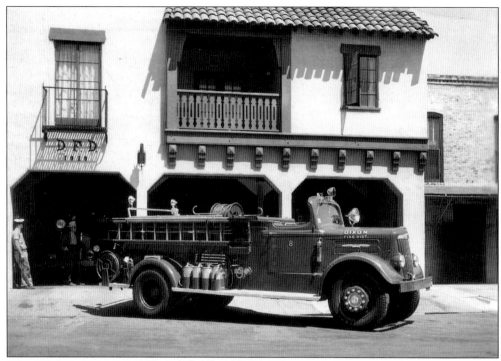

This old fire station was designed and built by architect George Rossi. Note the brick jail and court house on the right, which was demolished when the fire house was enlarged, c. 1940. (Courtesy of Dixon Fire Department.)

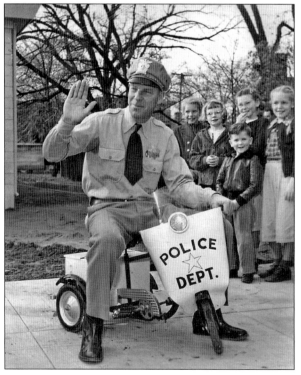

Police Chief Lester "Bud" Peters attends the dedication of city hall on January 20, 1951. The children in the background, from left to right, are Cathy Coleman, Kay Bradley, Pady Fielder, Timmy McCarthy, and Mary Mace. In Dixon's early years, law and order was maintained first by night watchmen, then sheriffs, constables, and marshals. In 1919, town trustees appointed Clay Grove to serve as marshal. He eventually assumed the title of chief of police.

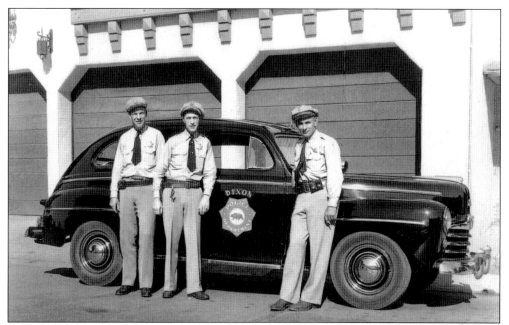

In 1946, the Dixon Police Department received their first patrol car and official uniforms. Here, Chief Bud Peters and officers Ray Crawford and Pete Murphy stand proudly in front of their new vehicle. Prior to 1946, the officers used their own automobiles for patrol. (Courtesy of Ardeth Sievers Riedel.)

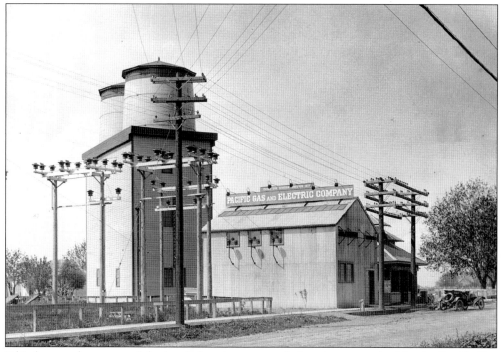

Ed Lehe was the owner of the local electric company before it was acquired by the Pacific Gas & Electric Company in the 1920s. This photo shows the substation and office bungalow on West A Street where the current substation is still housed.

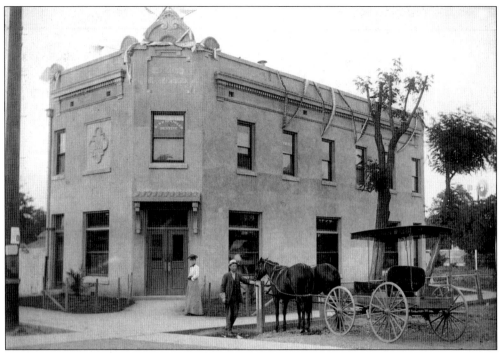

This building is the first permanent Dixon Post Office built in 1908 by Oscar Schulze. The town had one of the longest rural routes in California and delivered mail over 130 miles per day, 20 of which were on dirt roads. Even though letters were simply addressed to the name of the person and the city, they reached their destinations. The original Dixon Post Office was moved to town from Silveyville in 1869 when William B. Ferguson was the first postmaster. Then in 1908, this new post office was built on the northeast corner of First and B Streets. Office space upstairs included Dr. Wrigley's dental office. Local legend says that he kept a shotgun by the window in case he witnessed a bank robbery across the street. In this photo, Dr. Wrigley stands next to his horse.

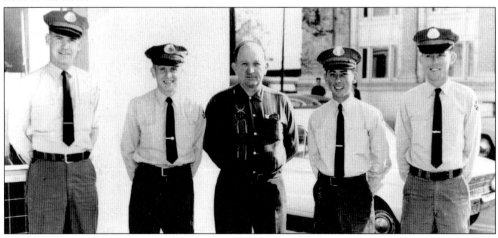

Dedication of the current 6,909 sq. ft. post office at 221 West A Street took place on July 17, 1965, when longtime postmaster James R. Kilkenny (center) was given the keys to the building. Pictured, from left to right, are Bud King, Glenn Fink, Kilkenny, Raymond LaBlane, and Jim Everett. (Courtesy Alan Schmeiser.)

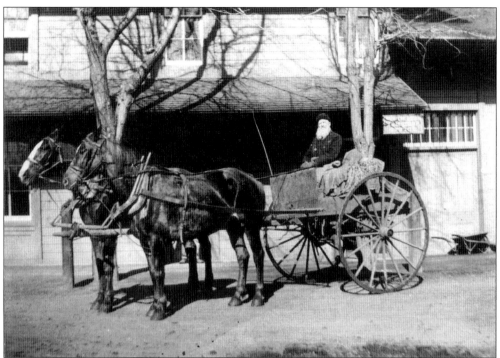

For more than 20 years, George "Pap" Hulen delivered mail daily between Dixon, Maine Prarie, and Binghampton. During the many winter floods, "Pap would take a boat from just beyond the cemetery to deliver mail to Maine Prarie. The larger axle and wheels allowed access through high water.

This female postal worker from the 1920s is shown with the new postal car on West B Street. The train station can be seen in the background.

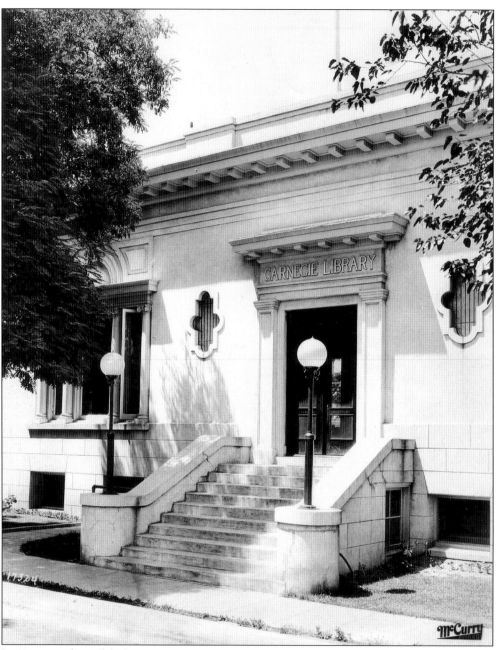

In 1911, members of the Dixon Women's Improvement Club decided that the community needed a library. Mrs. R.J. Currey, club president, wrote Andrew Carnegie asking for his assistance in building a library to serve the town's 827 citizens. After considerable correspondence, the city received a Carnegie grant of $10,000 for the library. Carolyn Schulze donated the land, which included the Women's Improvement Club Park. When it was dedicated in February 1913, it became known as the Dixon Union High School District Library, also known as the Carnegie Library and the Dixon Public Library. Dixon was the first town in Solano County to have its own public library. Carnegie public libraries were built across the United States between 1889 and 1923. Today 37 of the 142 libraries built in California are still in existence.

Five

CHURCHES

Churches provided a formal social life for the Dixon community. The Baptist church, built in 1877, was located on the west side of First Street between A and Mayes and had the more wealthy parishioners. They had the finances to build a structure with beautiful stained glass windows. The Methodist church was moved from Silveyville. Since the log rollers could not clear the railroad tracks, the church settled on the west side of the railroad, corner of B and Jefferson Streets. The original Catholic church, which became St. Peter's Hall, was located on Second Street between A and Mayes Streets. The Lutheran church, housed the only pipe organ in town, and stood opposite the Catholic church. The Congregational church, which has also disappeared, was located on the site of the present post office.

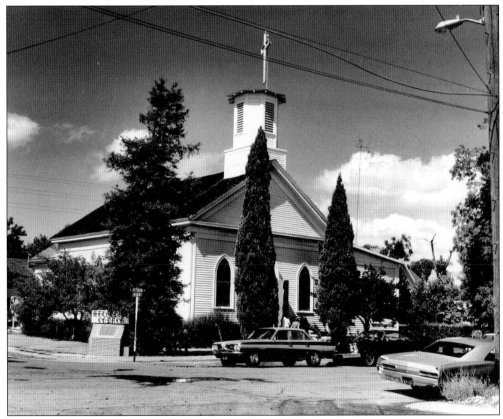

The Methodist church was the first church in Dixon. (Courtesy of Harold Axelson.)

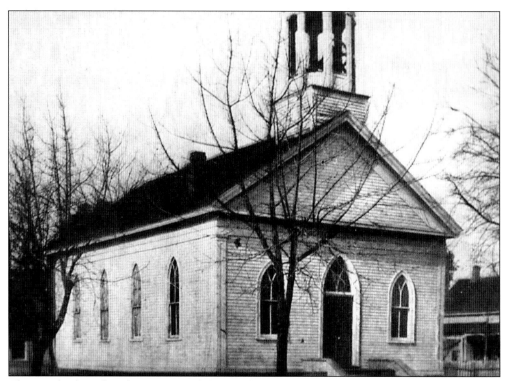

The Methodist church was moved from Silveyville in 1870, traversing three-and-a-half miles with the help of 40-mule teams and log rollers aided by many strong men. Unable to clear the railroad tracks, it stopped at its present site on the corner of Jefferson and West B Streets. Thomas Dickson sold the property to the church for the price of $1. This historic building is still used today by the congregation of the Methodist church. (Courtesy of Ardeth Sievers Riedel.)

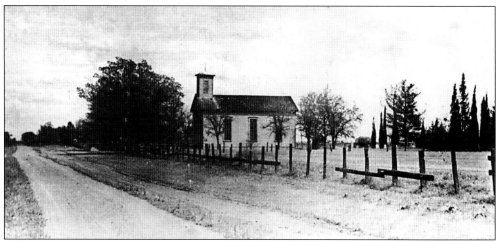

The Tremont Church, white-framed and of simple elegance, is more than 100 years old and stands on peaceful farmland between Davis and Dixon. Although the church was dedicated in 1871 it was not yet fully paid for, and so the Tremont Mite Society continued to meet and raise funds. While the church is no longer used today, except for an occasional wedding or funeral, it is maintained as a historical site.

In 1875 plans were made to construct the German Lutheran Church, which was built opposite St. Peter's Catholic Church near the corner of Second and Mayes Streets.

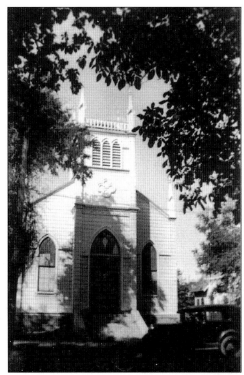

Pictured here is the inside the old German Lutheran Church. It was the only church in town with a pumper organ.

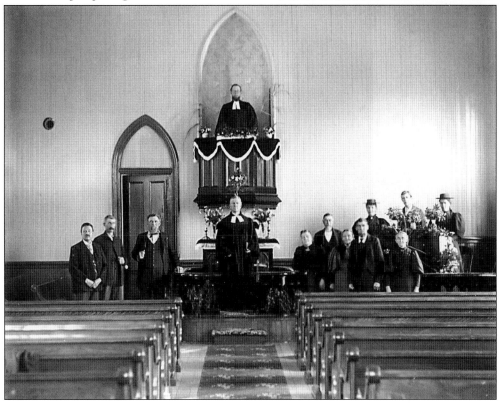

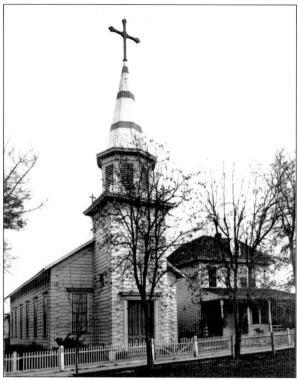

This Catholic church was built as a mission in Dixon in 1868 and was erected in the location of the existing parking lot on Second Street between A and Mayes Streets.

The present St. Peter's Catholic Church, right, was constructed in 1915 and still stands today on the corner of East A and Second Streets.

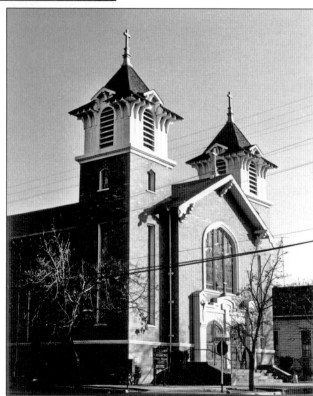

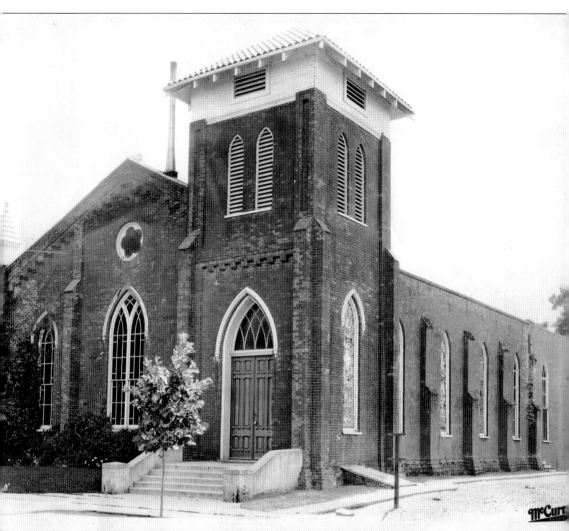

In 1877, the First Baptist Church was constructed on South First Street for $12,000. It survived the Great Fire of 1883. The pointed spire was removed after the earthquake of 1906. When this building was torn down, eight of the stained glass windows were carefully removed and replaced as the new windows for the Dixon Community Church.

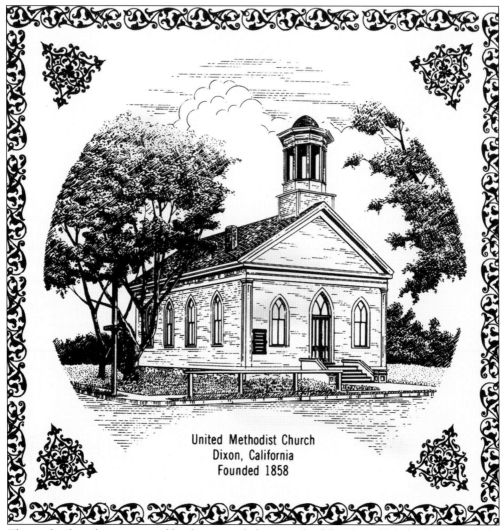

United Methodist Church
Dixon, California
Founded 1858

The art for this tile was inspired by the original photograph of the United Methodist Church. In 1989, the Grace Circle (a church organization) produced 100 tiles and 100 cups using this picture. This was the year that a consecration service of the new fellowship hall was held—123 years after the building was first erected.

Six
SCHOOLS

When California entered the Union in 1850, the new constitution provided for the establishment of free elementary schools. Before buses and carpools, earlier generations of Dixon students attended small schools in strategic locations around the county. Currey, Solano, Tremont, King, Binghampton, Pitts, Grant, and Silveyville were districts as well as schools, serving Dixon children in rural areas. Old-timers recall days of walking to school as well as riding a horse or pony. The youngsters tied the animals up during classes and rode home at day's end. Prior to 1912, schools were wooden structures; after 1912 they were made of sturdier materials like stucco and were constructed in a Mission-style design.

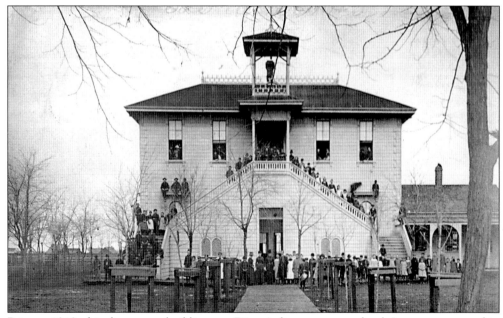

Prior to 1912, this three-story building was Dixon's first grammar school. It was constructed in 1872 on East C Street.

Solano School, on Tremont Road, was a small one-room building with all eight grades. This was the Solano Joint School and only had about 10 students. In 1925, they had become so small that the county closed it and students began attending the Dixon schools. Note from Jean Sikes graduation speech: "A wood stove provided heat in the winter. There was no running water, just a well with a hand pump and there were privies across the school grounds, one for boys and one for girls. These took the place of flush toilets."

Solano School pupils in 1925 included Jack Sikes (the tall boy in back), and Alta Eggert and Jean Sikes, who were the only two girls in the school. Here is an excerpt from Jean Sikes' graduation speech:

> Most of the time Jack and I walked to school about one and a half miles from our home. We didn't have much of any supervision on the playground. When we went out for recess or lunch hour we were on our own. If we chose to go down and play in the slough, we were free to do so. This was especially fun when the teacher had her boyfriend come to visit during lunch hour. We would get an hour-and-a-half or two hours for lunch." (Courtesy of Pat Pipkin.)

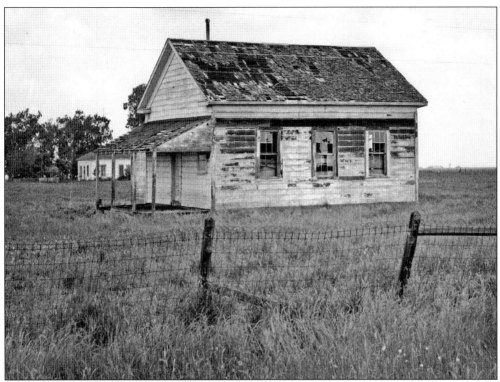

These photos show an aged Maine Prairie School, which was torn down in 1988. (Bottom photo courtesy of Harold Axelson.)

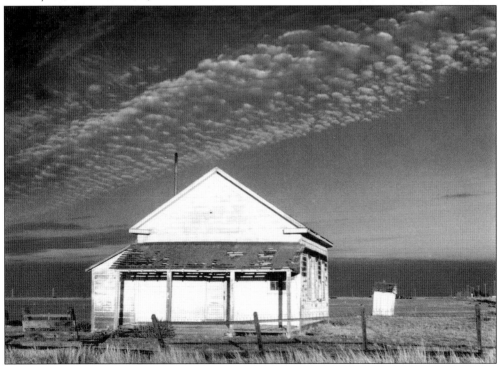

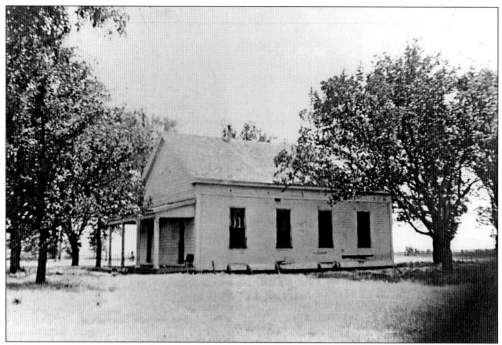

Pitts School was a one-room, rural country school dedicated on February 14, 1868, serving grades one through eight. It was governed by a small local school board and was under the jurisdiction of the county. (Note: Pitts School with an extra "s" was the name in the early days; today the name is carried on as Pitt School Road.)

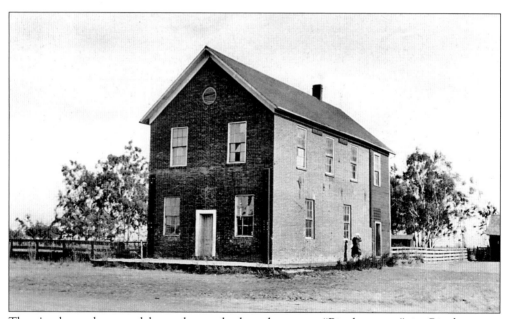

There's always been a debate about whether the name "Binghampton" in Binghampton School is spelled with or without a "p." The authors couldn't find the answer to this, so the debate continues.

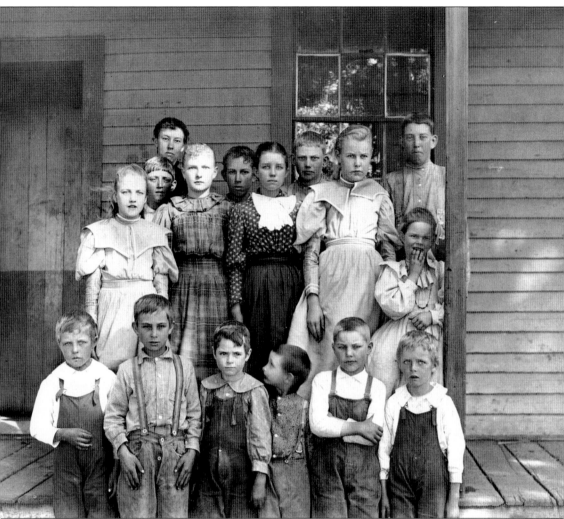

These students attended Grant School in 1894, one of the only rural schools still standing today. Members of the same family can be identified by the similarity of the clothing. In the early 1800s, mothers did most of the sewing and would pick up a bolt of fabric from the general store to make clothing for their children. (Courtesy of Ardeth Sievers Riedel.)

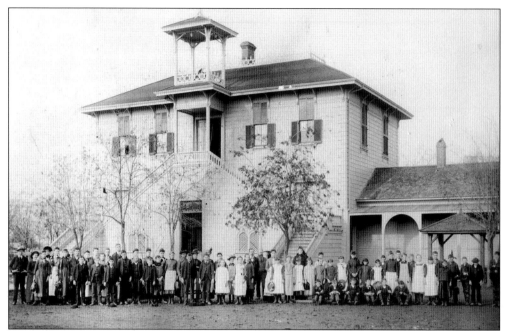

Dixon Grammar School, located in the 400 block between East C and D Streets, was erected in 1872 for $2,000. Around 75 students attended the first year under the tutelage of Miss Lizzie Brown and Mr. M. T. Sicknall. By 1878, approximately 200 students were enrolled.

Dixon's newest elementary school was named after a popular teacher, Miss Gretchen Higgins, shown here with her 1925 third and fourth grade class. Two of her students can be identified: Phyllis Watson Houlding, back row, second from left, who was raised on the Watson Ranch, and Bud Rossi, (back row seventh from left) who still lives in Dixon today. Everybody loved Miss Higgins, including Bud Rossi—until she made him dance a minuet with a girl. (Courtesy of Bud Rossi.)

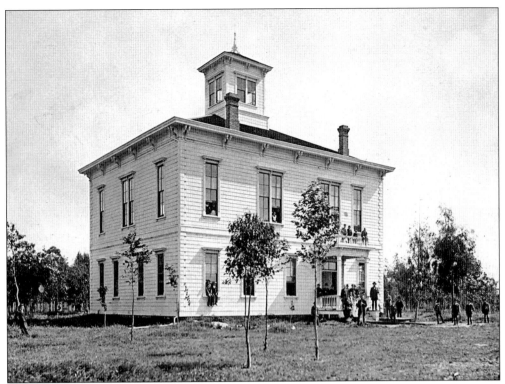

Dixon Academy, a private school, was the forerunner of the present Dixon High School. Plans to convert Dixon Academy to a union high school began in 1891. The school was renovated and standards of admission were raised. To enter the school, students had to pass an examination and receive 80 percent or better in math, grammar, geography, history, and physiology. A monthly tuition of $5 was charged and the school opened in August 1892. Dixon High School celebrated its 100th anniversary with the graduating class of 1993.

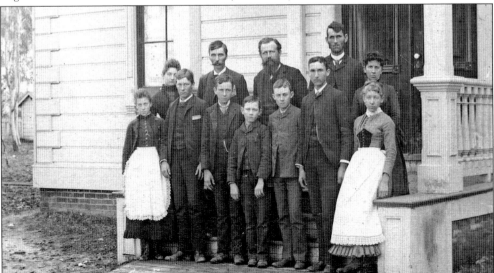

C.A. King operated a private school that provided education beyond the eighth grade. The student body is shown above, c. 1890.

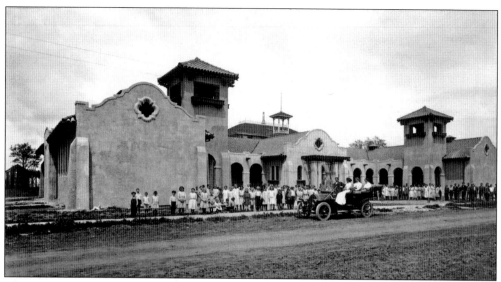

A new Dixon Grammar School was built in 1912 for $25,000 and was a fine example of Mission-style architecture. It occupied a whole block at the site where Anderson School stands today. Look closely and you can see the original grammar school behind it. (Courtesy of Wes and Joanne Jacobs.)

C.A. Jacobs, in the shadows, looks on as four students descend the stairs. (Courtesy of Wes and Joanne Jacobs.)

C.A. Jacobs reflects on the past as he sits on the front steps of the Dixon Grammar School. (Courtesy of Harold Axelson.)

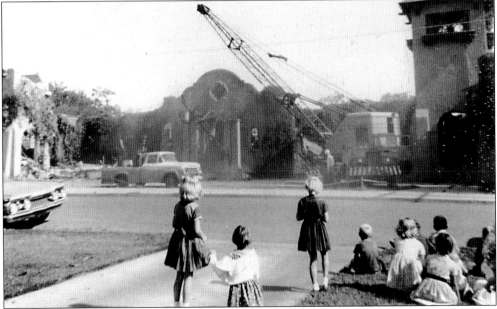

A group of students watch the demolition of the Dixon Grammar School, c. 1960. The Anderson School occupies the site today.

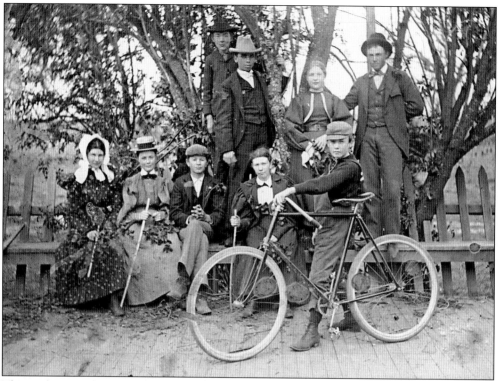

The graduating class of 1898 enjoys a jaunt to Armstrong's Grove in Yolo County. (Courtesy of Ardeth Sievers Riedel.)

This photo is from the Barbara McCune files. She is one of the seven students in this 1901 graduating class. (Courtesy of Ardeth Sievers Riedel.)

It was a tradition for the graduating class to perform their own play with everyone in the class participating. This is the class of 1901. (Courtesy of Ardeth Sieves Riedel.)

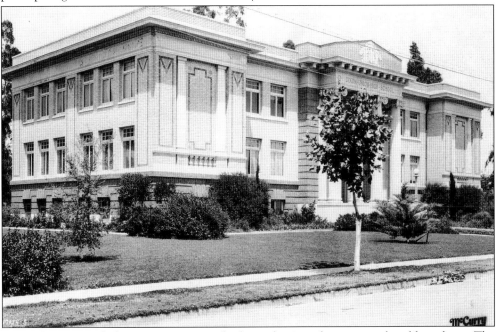

In 1915, a new and elegant structure was built on the same location as the old academy. The present Dixon High School, on Fourth and West A Streets, was completed in 1940. (Courtesy of Ardeth Sievers Riedel.)

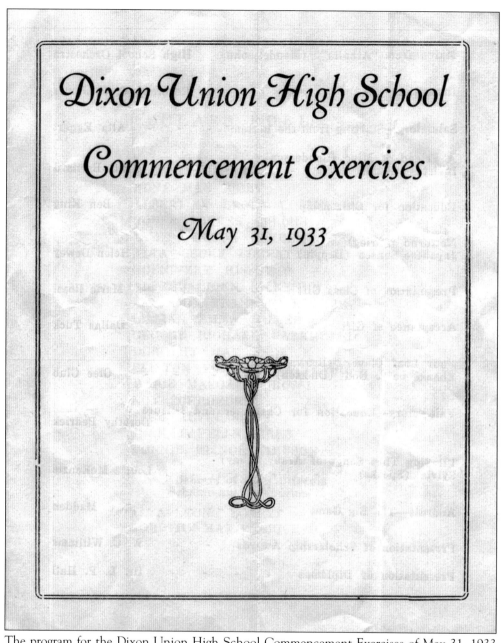

The program for the Dixon Union High School Commencement Exercises of May 31, 1933 listed the names of all 18 graduates. (Courtesy of Pat Pipkin.)

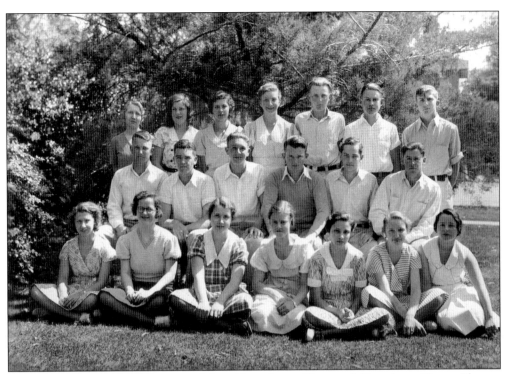

Faculty member Florence Eggert with her 19 students; (first row) Guenivere Hissey, Eleanor Ashby, Bonnie Simpson, Jean Sikes, Marie Rossi, Alta Eggert, and Albertine Collier; (second row) James Coveney, Ben King Jr., Roy Schroeder, Alfred Kilkenny, Clifton Rattenbury, and Robert Collier; (third row) Florence Eggert, Edna Bibby, Dorothy Pedrick, Lillian Miller, Jack Sikes, Richard Parkhurst, and unidentified. Below is the graduation program for May 31, 1933 commencement exercises.

March from "Athalia" (Mendelssohn)	High School Orchestra
Invocation	Reverend C. C. James
Salutatory—Starting from the Bottom	Alta Eggert
A Friend of Mine (Sanderson) Invictus (Huhn)	Bill Barnard
Education for Citizenship	Ben King
Notturno (Grieg) Japanese Sunset (Deppin)	Helen Dewey
Presentation of Class Gift	Marie Rossi
Acceptance of Gift	Dallas Tuck
Four Leaf Clover (Brownell) Thanks be to God (Dickson)	Glee Club
Valedictory—Education for Character and Leisure	Dorothy Pedrick
I'll Sing Thee Songs of Araby (Clay) Sylvia (Speaks)	Louise McKenzie
Address—The Big Game	A. C. Madden
Presentation of Scholarship Awards	W. C. Williams
Presentation of Diplomas	Dr. L. P. Hall

CLASS ROLL

ELEANOR ASHBY
EDNA MAE BIBBY
ALBERTINE LEOLA COLLIER
ROBERT BURNS COLLIER
JAMES VICTOR COVENEY
ALTA LEONE EGGERT
GUENIVERE HISSEY
ALFRED LIDEN KILKENNY
BENJAMIN FRANKLIN KING Jr.
LILLIAN EMMA MILLER
GEORGE RICHARD PARKHURST
DOROTHY MAY PEDRICK
CLIFTON FORREST RATTENBURY
MARIE MARGARET ROSSI
ROY SCHROEDER
JACK ALVIN SIKES
JEAN LAVELLE SIKES
BONNIE ELINOR SIMPSON

Seal Bearers of the California Scholarship Federation

ALTA LEONE EGGERT
DOROTHY MAY PEDRICK

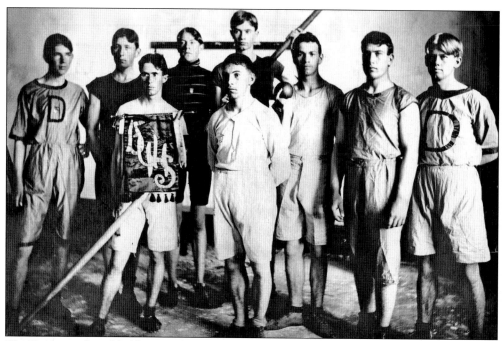

The Dixon track and field teams, from left to right, are (front row) Clarence McBride and Jerry Hall; (back row) Cecil Ferguson, Otto Eggert, Stuart Grady, Scott Rice, Jo Hall, Wilbur Eibe, and Wallace Petty.

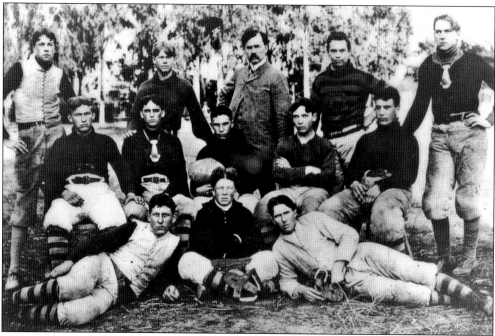

Posing in this well-known 1901 picture are members of Dixon High School's first football team. From left to right, they are (front row) Otto Eggert, Ray Grinstead, and Clary McBride; (seated) Jake McElwaine, Harry Foster, Jerry Hall, Bee Sweany, and Wilbur Eibe; (standing) Stuart Grady, Wallace Petty, Professor Grinstead, Joe Hall, and George Steinmiller.

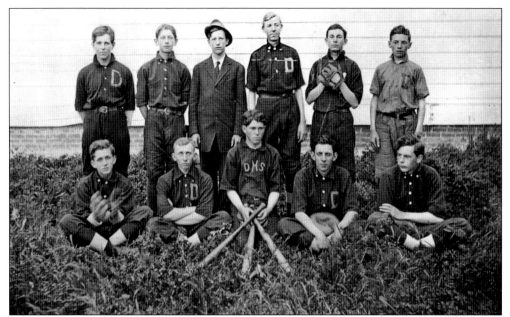

In the early 1900s, Dixon High School baseball was a fall and spring sport and there were both boys' and girls' teams. This 1910 Dixon High School baseball team from left to right are (first row) Eggert Rohwer, Harold Pousilaire, Lowell Eames, Jerold Cowden, and Donald McFadyen; (second row) George Foster, Ray Rohwer, Carl Scherer, Warren Lehe, Bob Hope, and Herman Fisher.

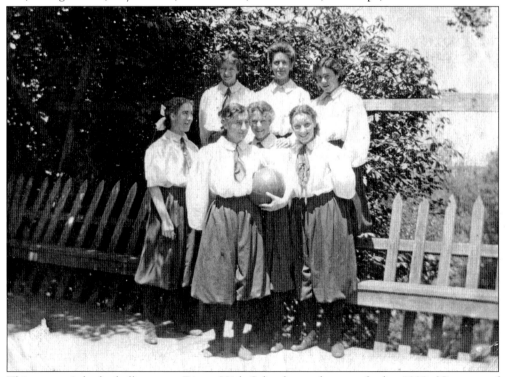

This women's basketball team at Dixon High School was photographed c. 1900. (Courtesy of Marda Rowe Henry.)

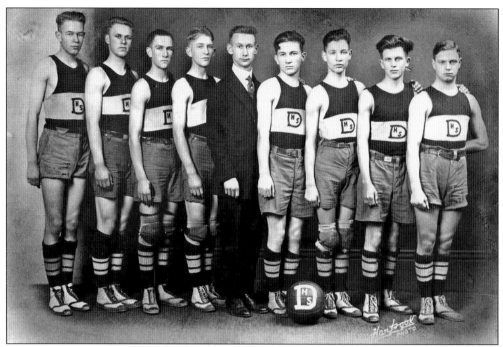

The Dixon High School basketball team of 1921 was coached by the much loved Chris A. Jacobs. C.A. Jacobs Intermediate School was named in the coach's honor. Members of the team, from left to right, are Jack Rice, Vernon Schmeiser, Adolph Hendricks, Otto Rohwer, Jim Kilkenny, Francis Watson, Bud Eames, and George Rossi. (Courtesy of Wes and Joanne Jacobs.)

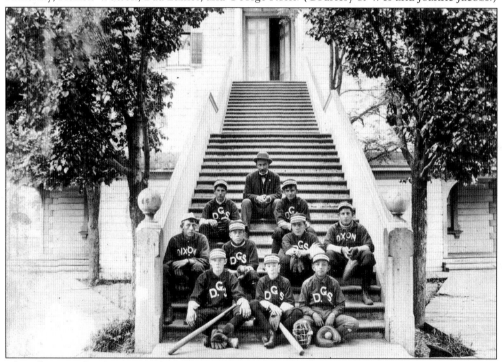

This photograph of a Dixon Elementary School baseball team was taken in the early 1900s.

Seven

HISTORIC HOMES

The homes pictured here were built in the latter part of the 19th to the mid-20th century. Some have been razed but many have been remodeled and are beautifully maintained today. The town's earliest residential area was largely developed on the east side of the railroad tracks, while the expansion on the west side began after World War I, and then continued rapidly after World War II and the completion of Interstate 80.

The Dickson home was built in 1858 with lumber hauled from Grass Valley. The foundation was stumps of manzanita from the hills. The house was occupied by members of the Dickson family until it was sold and subsequently demolished in 1922. Pearl Monahan (on the left) was the daughter of Emaline Dickson Monahan (born in a covered wagon in 1853) and the granddaughter of Jane Dickson. Ina M. Dodge (on the right) was the granddaughter of Martha Dickson Duffield and the great-granddaughter of Jane Dickson.

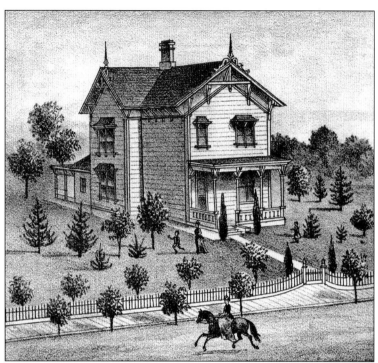

This drawing of the D.L. Mann residence was taken from the 1878 *Historical Atlas of Solano County*. This home is still located on North Jefferson Street facing the railroad tracks. (Courtesy of Ardeth Sievers Riedel.)

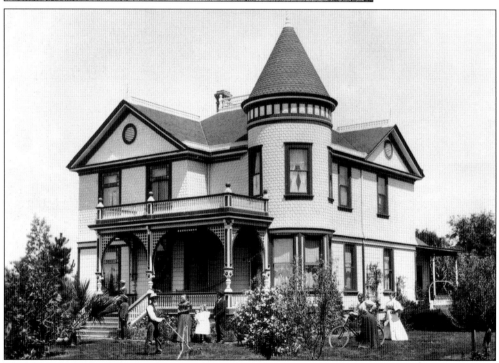

This home was built by Lena Jahn Stick Eggert and Claus Eggert in 1895 on Tremont and Eggert Roads. Their children were Lena Stick Rohwer, Amanda Stick Runge, Herman Stick, Edmund Eggert, Otto Eggert, and Elda Eggert. Descendants still own and farm the ranch. (Courtesy of Pat Pipkin.)

Joachim Schroeder, an immigrant from Germany, settled in Dixon in 1866 and built his family home in 1874 for $3,000. He and his wife raised eight children there. When Silveyville's businesses and homes were moved to Dixon, Schroeder helped relocate graves. The event was memorialized by naming the Dixon cemetery Silveyville Cemetery. (Courtesy of Pat Pipkin.)

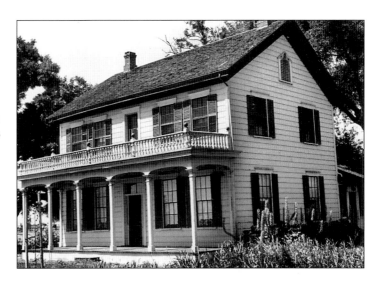

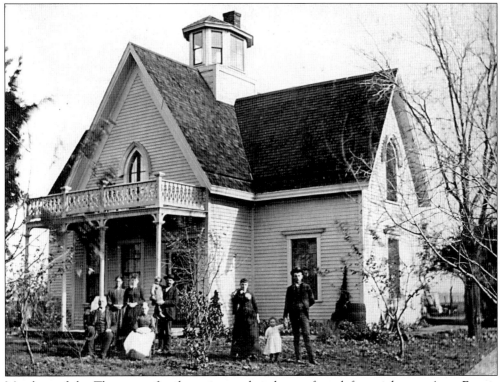

Members of the Thompson family posing at their home, from left to right, are Aunt Fannie Thompson, Grandma Thompson, J.W. Marshall, Cora Marshall, Mary Lou Marshall, Uncle Charlie Thompson, ? Matt, and Lucy Thompson. Bernice Marshall Watson wrote, c. 1898, "I sure loved this old house when I was a small fry. I always headed for the cupola on the top. That was just grand: it had a bench clear around it on the inside to sit down and enjoy the view." (Courtesy of Phyllis Watson Houlding.)

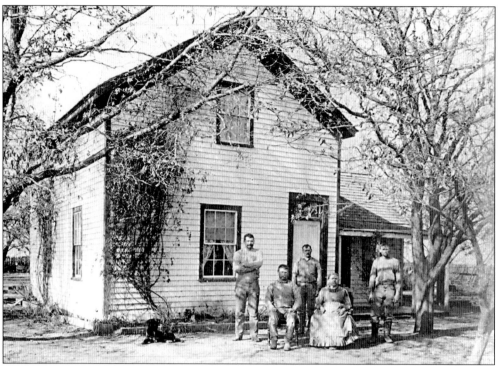

This original Rayn home on Pedrick Road was destroyed by fire in 1897. It was rebuilt in 1898 but succumbed to another fire in 1945. (Courtesy of Barbara Rayn Beckworth.)

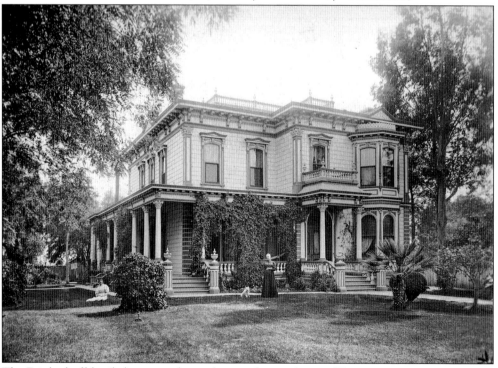

The Brinkerhoff family home was located two miles northeast of Dixon.

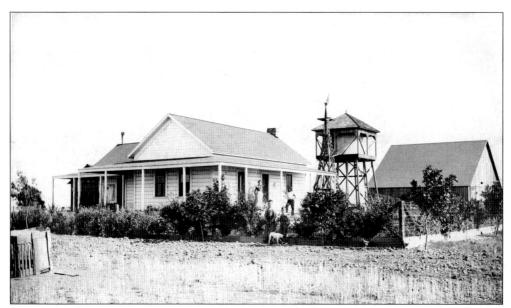

The old ranch home owned by Dick Sparks had a windmill and water tower.

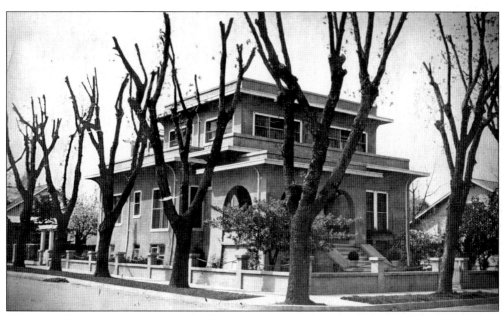

Showing influences of the prarie style of architecture, this stucco home at East Third and Mayes Streets was owned by Amelia Petersen Moss and Rowland Moss for many years. Originally a much smaller house, it has been remodeled extensively. Most of the black walnut trees are gone today. (Courtesy of Ardeth Sievers Riedel.)

This house at the corner of B and Second Streets was built and owned by John Rice, Bank of Dixon president, c. 1916. The matching rock garage is pictured below. (Courtesy of Ardeth Sievers Riedel.)

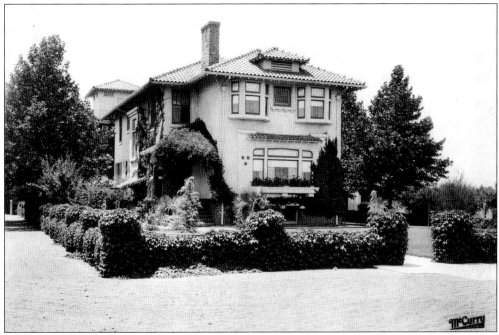

This home was built in 1913 by Henry Peters on a 40-acre plot of land. The surrounding acreage had a variety of fruit and nut trees, and concord grapes lined West A. The house has a wall-to-wall basement, an upstairs poolroom, servants' quarters and an elaborate buzzer system to summon the maid. Note the tank house in the back. (Courtesy of Ardeth Sievers Riedel.)

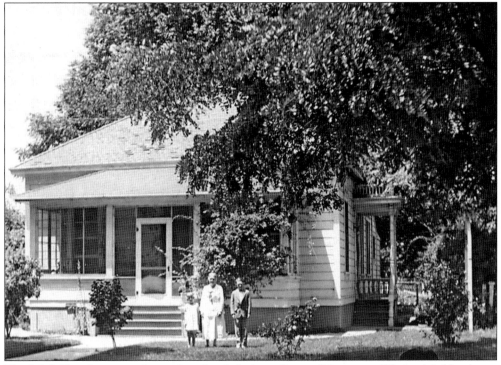

The J.A.J. King home was located on South Jackson Street. (Courtesy of Nancy Madden.)

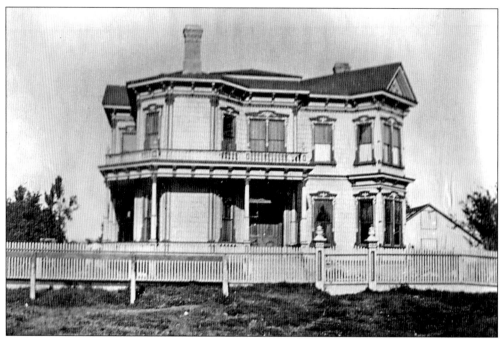

One of the Brown family's early homes was located off of Highway 113. The Brown family lost several members to tuberculosis and pneumonia between 1912 and 1914, including Mr. Brown, the father, and his three daughters. Immediately after their deaths, the house was burned. The foundation of the home remains to this day.

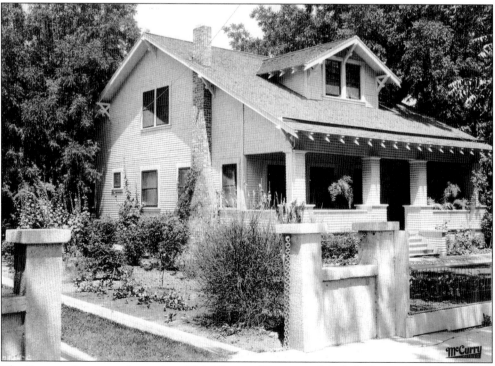

The Sweeney home was located on Third Street. (Courtesy of Ardeth Sievers Riedel.)

Eight
PEOPLE

Dixon has been home to many characters who have shaped this town and whose stories have not been forgotten: ranchers, butchers, cooks, bartenders, storekeepers, teachers, car dealers, inventors, entertainers, agricultural workers, auctioneers, and more. They have all made Dixon their home. Dixon is small, and people know each other, rely on each other, cry for each other, and entertain each other.

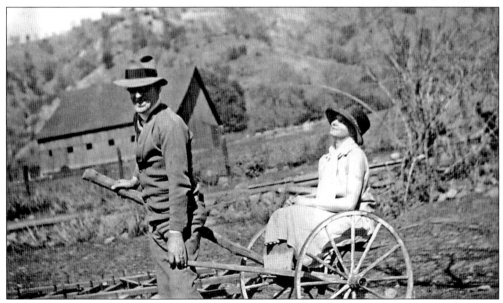

Al Alexander, who owned one of the two butcher shops in town, provides the power for a cart ride enjoyed by Anna Gerlach. (Courtesy Ardeth Sievers Riedel.)

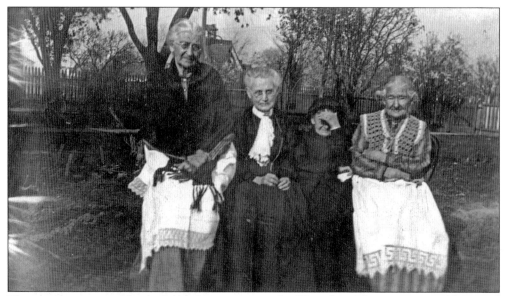

The note written on the back of this picture reads, "Grandma Thompson's neighbors and friends. They visited every day and usually gathered at Grandma Thompson's, sat around the fireplace and smoked corn cob pipes." Shown, from left to right, are Mrs. Hornback, Grandma Dodge, Grandma Thompson, who has her hand over her face to shield herself from the sun, and Grandma Dickson (the town was named Dixon after her family). (Courtesy of Phyllis Watson Houlding.)

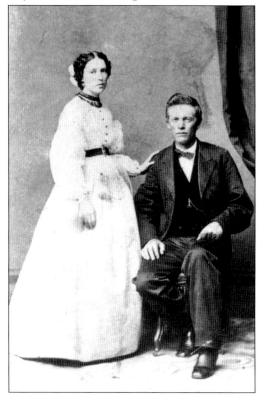

Missouri Lewis and James Adoniram Judson King were married on July 3, 1867 at the Maine Prairie Hotel, which was owned by Missouri's mother, Rebecca Barr Lewis. The Kings lived on a ranch on King Road where they raised seven children. They later moved into a house on South Jackson Street built by their son George. (Courtesy of Nancy Madden.)

Anna Pahl Timm (1804–1897) moved to Dixon late in life to live near her sons Hans Timm, Peter Timm, and Joachim Schroeder. The Timm and Schroeder families were able to acquire large farms in the Dixon area and were prominent members of the community. All were born in Schleswig-Holstein, Germany, and came to Dixon in the 1860s. (Courtesy of Pat Pipkin.)

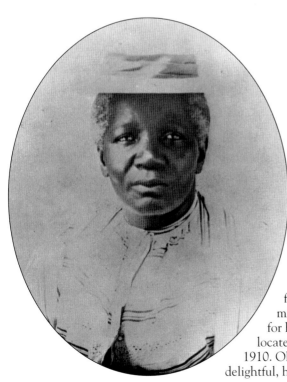

Originally a slave, Nancy Geary was brought to Batavia by the Duke family from Missouri, where she served as a midwife and nurse. Later, she was known for her ice cream and her store, which was located in the "Old Corner" building prior to 1910. Old-timers have fond recollections of this delightful, hardworking lady.

Shown here in a photo from the turn of the century are sisters Rose (1884–1961) and Anna (1882–1910) Schroeder, born of Joachim and Gretchen Rohwer Schroeder and raised with six brothers. Anna died of measles at the age of 28. Rose married Otto Eggert, a farmer in the Tremont area. They had three daughters: Della (Mrs. W.H. Jones), Florence (Mrs. Marian Neal), and Alta (Mrs. M.J. Wolfe). (Courtesy of Pat Pipkin.)

Elda Eggert was the youngest daughter of Claus and Lena Eggert and was born in 1890 on the Eggert Ranch in Tremont, near Dixon. She graduated from Dixon High School in 1907 and then obtained a master's degree from U.C. Berkeley. She taught German and Latin at Dixon High School prior to World War I, when the course was eliminated from the curriculum. She died in 1980. (Courtesy of Pat Pipkin.)

Arthur Joseph Brown was responsible for building the Dixon Livestock Auction Yard in 1939. The yard's first weekly Wednesday auction total was $1,400 and in the peak years was known to bring in over $50,000 per week. (Courtesy of Alan and Heidi Brown.)

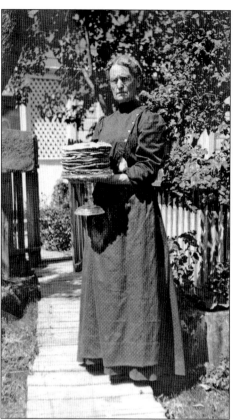

Posing in front of her home at 234 East A Street, Mrs. Basil Stephens displays one of her famous 14-layer cakes. She was the daughter of Harden Reddick, a pioneer of Silveyville.

Emil Rossi and a friend motor to Sacramento across the Yolo Bypass in 1915 before paved roads and the causeway existed. Note the steering wheel on the right side. This road was only open during the summer, when all the flood waters were dried up. To drive to Sacramento, most of the time you had to drive to Woodland, where they built the first causeway. (Courtesy of Bud Rossi.)

Pictured here is the Peters family, George Amiel Peters Sr. and Gretchen Margaret Scheel Peters, children Gladys Alwina Peters (future wife of C.A. Jacobs) and George Amiel Peters Jr. (brother of future chief of police Lester "Bud" Peters). This family came to Dixon in the 1800s. (Courtesy of Wes and Joanne Jacobs.)

Milton "Babe" Rayn poses beside his Model T Ford in 1942. Note the gas ration stamp on the windshield. (Courtesy of Barbara Rayn Beckworth.)

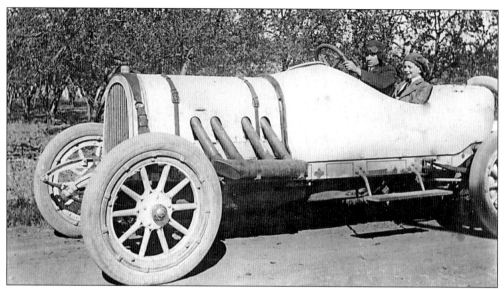

Emil Rossi sits at the wheel of a Pope-Hartford racer. Seated next to him is his nephew George Rossi. Emil was employed by Dixon farmer Roy Mayes to maintain his automobiles and drive his racecars. Many of these cars were entered in West Coast events between 1910 and 1912. George Rossi went on to become a well-known architect and designed several buildings and homes in the area, including the old Dixon Fire House. (Courtesy of Bud Rossi.)

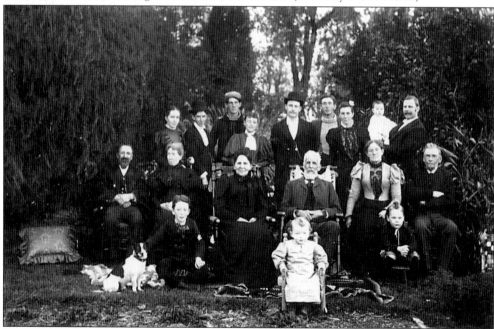

The McFadyen family, originally from Prince Edward Isle, came to California in the 1860s. J.W. McFadyen (center) was soon joined by Mary Jane and her sister, who crossed the Isthmus of Panama to join their brother in 1867. Mary Jane married John Rightmire Madden (far left). Their son, Angus Madden (child kneeling with dog on front left) became a prominent banker after whom Madden Hall is named. Harry McFadyen (young man in back row with cap) became president of the Solano County Fair in 1916. (Courtesy of Nancy Madden.)

These old-timers, who saw Dixon's first May Day Fair in 1925, gathered on J.D. Johnson's lawn. Shown, from left to right, are (front row) ? Gill, Mary Petersen, J.D. Johnson, ? Ford, Mrs. J.A.J. King, and ? Hyde; (back row) B.F. Newby, Mrs. Velora Holly, Elmer Nudd, Mrs. C. Ferguson, and John Branton. (Courtesy of Ardeth Sievers Riedel.)

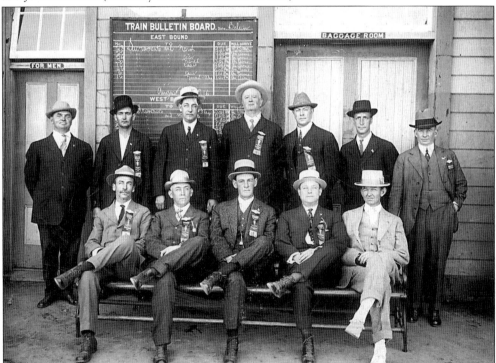

Directors of the first Solano County Fair in 1916, from left to right, are (front row) Mr. Mills, county farm advisor; Mr. William Garnett, farmer; Mr. Harry McFadyen, president of the fair; Mr. Ike Beckley, haberdashery owner; and Mr. W. Weyand, owner of the California Meal-Alfalfa Company; (back row) Julius Weyand, bandmaster of the Dixon Community Band; unidentified; Dr. Hall, physician and banker; John Rice, banker; Stuart Grady; Rev. Sam Wilson, minister of the United Community Church; and W.R. Madden, rancher and banker. (Courtesy of Alan Schmeiser.)

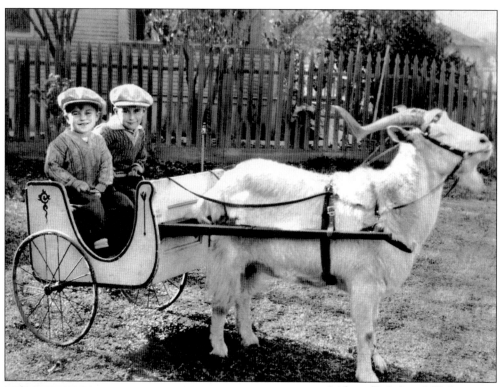

Milton (Babe) and Walter Rayn are ready to enjoy a "goat-cart" ride. In the background, Ralph Mack peeks through the fence.

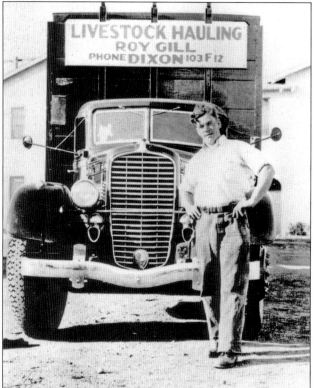

Walter Fuschlin is shown here with his 1938 Diamond T truck at the Gill Ranch on Currey Road. Eventually he bought Gill Trucking, starting his own business, Valley Livestock Trucking. He is remembered for being a character who loved to play practical jokes.

Nine
ORGANIZATIONS

Organizations are the backbone of most communities and support a multitude of purposes. Dixon is no exception. Local service organizations include Lions, Rotarians, and Boy Scouts. Fraternal and social organizations include Masons, Odd Fellows, American Legion, Eastern Star, Rebeccahs, Native Daughters of the Golden West, Grange, Grey Ladies, Women's Improvement Club, and the Red Cross. These associations provide important social and business contacts for its residents. The members of the community benefit from their involvement in these services and the contributions that are made to the city.

In this c. 1950 Dixon Women's Improvement Club meeting, all the ladies were wearing hats and carrying gloves.

Above is a *c.* 1920s Dixon Women's Improvement Club picture. The organization, originally called the Shakespearean Club, was founded in 1899 and is the oldest service organization in Dixon. The WIC was one of many established throughout the country. The purpose of the group was to contribute to the civic and social well being of Dixon. At one time, even though members were told that Dixon was too small for a library, they defied the odds and established the first one in Solano County. They had to change federal legislation to do this, but do it they did.

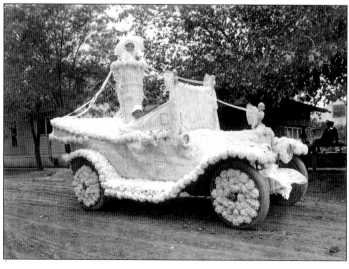

On the left is a Dixon Women's Improvement Club float entered in the May Fair parade, *c.* 1905.

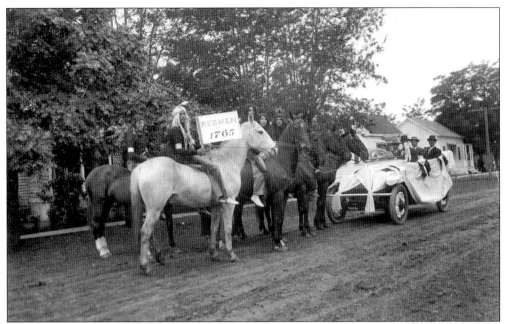

This Order of Redmen parade entry dates from the late 1800s. The Order of Redmen is the oldest fraternal organization in the United States. It was founded before the American Revolution. The club believes in love and respect for the American flag; preserving the nation by defending and upholding the principles of free government, America, and the democratic way of life. Redmen help their fellow man through organized charitable programs and keep alive the customs, ceremonies, and philosophies of the Native Americans.

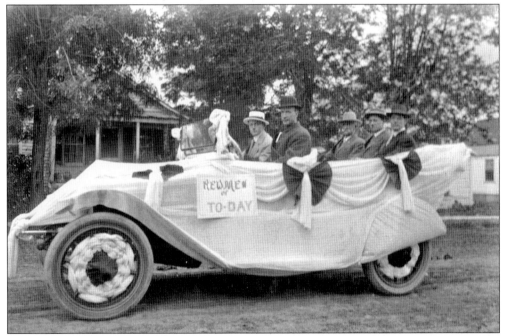

"Redmen of Today" was the entry which followed the horses and can be seen to the right in the top photo.

The Native Daughters of the Golden West entered this float in the May 7, 1938 May Fair parade. J.D. Johnson's Hardware store, now Dawson's, is visible in the background. Next door is an ice cream store that is now Robben's Department Store. (Courtesy of Alan Schmeiser.)

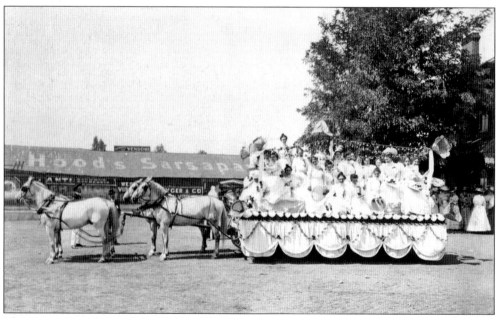

The Native Daughters of the Golden West is a patriotic organization dedicated to preserving California's history. Members must be natives of California to join. (Courtesy of Ardeth Sievers Riedel.)

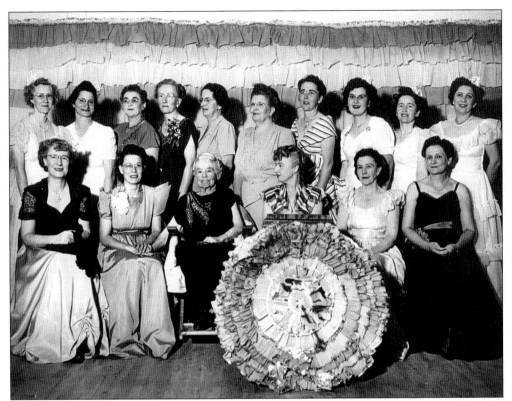

The Native Daughters of the Golden West organized in Dixon in 1888. In 1923, the organization was renamed Mary E. Bell Parlor in honor of one of its members. It still has an active membership today.

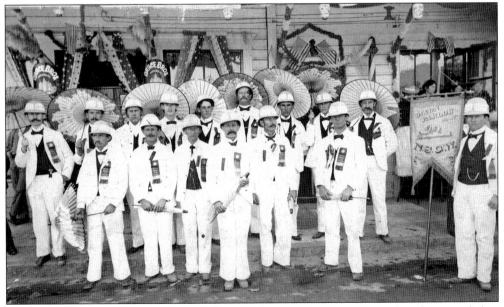

This is how Dixon's chapter of Native Sons of the Golden West appeared as they paraded in Santa Rosa on September 9, 1897. (Courtesy of Alan Schmeiser.)

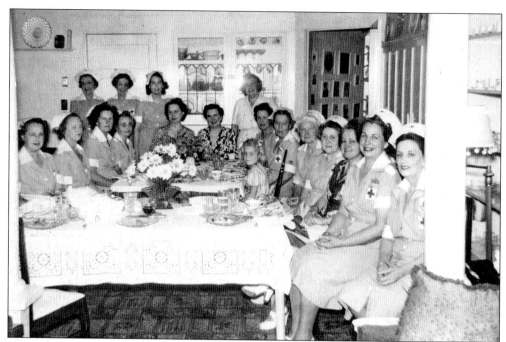

In this 1946 picture, the Grey Ladies were a part of the American Red Cross who visited Travis Air Base Hospital, made cookies for the patients, and if needed, helped them write letters. (Courtesy of Ardeth Sievers Riedel.)

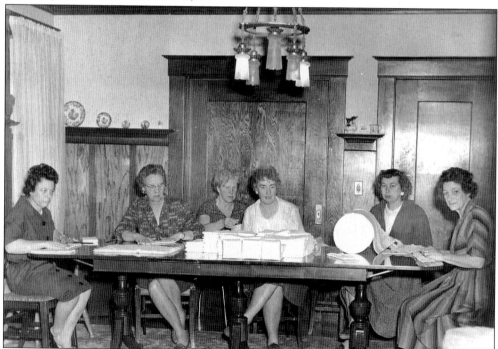

The Order of the Eastern Star is the feminine counterpart of the Masonic Lodge organization. In the late 1940s, they created work stations where members met regularly and rolled bandages for use in hospitals.

The Women of the Grange perform a skit at the Grange Hall IOOF building in the 1940s. Grange was a farm organization that formed to trade ideas on agriculture and canning tips. Seated at the table, center, is Murial Sievers with Gwendolyn Rohwer. Emma (Mrs. Walter) Anderson is on the far right. The girl with the bow is Betty Mae Carpenter Goodin. (Courtesy of Ardeth Sievers Riedel.)

American Legion Auxillary of 1947, from left to right, are (front row) district installer unidentified, Lorraine Sawyer, Lou Pringle, Thelma Inslee, and district lady unidentified; (back row) Lillian Bulkley, Muriel Sievers, Mable Thissell, Edith Rickettes, Carrie Belden, Marian Thissell, Lois Andrews, unknown, Rosyln "Rud" Tooley, Cleo La Montagne, and Evelyn Dutra. (Courtesy of Ardeth Sievers Riedel.)

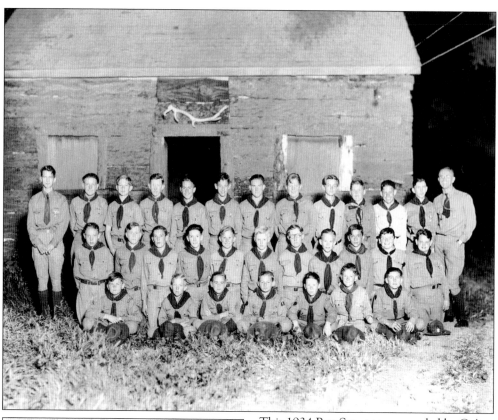

This 1934 Boy Scout troop was led by C.A. Jacobs (third row, far right). His son, Wes Jacobs, is in the middle row ninth from left. At that time, the scout hall was located by the fairgrounds, but has since been torn down. (Courtesy of Wes and Joanne Jacobs.)

"BE PREPARED"

This Boy Scout card was issued to Wes Jacobs in 1934. (Courtesy of Wes and Joanne Jacobs.)

Ten
1940S AND 1950S REVIEW

In the 1940s and 1950s, life in Dixon accelerates as its inhabitants became more modern. They trade in their Model Ts and drive Studebakers, DeSotos, Ramblers, Buicks, Oldsmobiles, newer Fords, and Chevrolets, moving faster and smoother so they can feel the winds of promise blowing through their hair. Highway 40 is built and is complete by the fall of 1940. The homestyle cooking that farm workers once depended on made way for "fast food" that could be eaten on the run, a trend begun by the Milk Farm and the Giant Orange before Taco Bell and McDonald's existed. New teachers and professionals move to Dixon bringing in the baby boom. Locals watch their new television sets and witness the beginning of wild marketing crazes advertising hula-hoops and yo-yos. New machinery is revolutionized. Old buildings are torn down to make way for new ones and old farms give way to developing subdivisions.

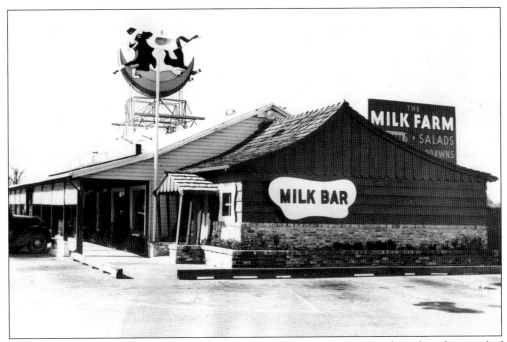

In 1939, Mr. Karl Hess anticipated the building of the new Highway 40 and purchased a parcel of land. The Milk Farm sign is a reminder of the famous roadside stop he built there and was visible from seven miles away. The Milk Farm was the official entrance to Dixon. People would often say, "Just turn south at the Milk Farm" when giving directions to town. (Courtesy of Larry Simmons.)

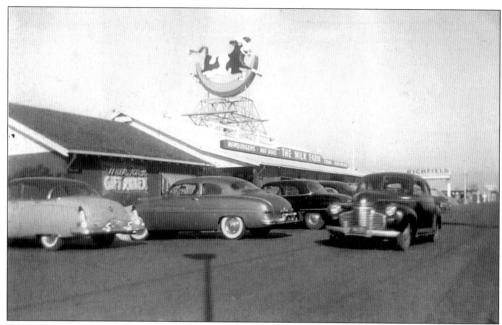

The name "Milk Farm" came from a story in the *Saturday Evening Post* magazine. Its defining feature was that 10¢ could buy all the milk or buttermilk one could drink, an offer that gave rise to milk-drinking contests. A record of milk-guzzling champions filled the blackboard that hung on the Milk Farm's wall. One man from Yuba City drank five quarts of milk in 20 minutes. Another man from Salt Lake City drank six quarts of buttermilk in 25 minutes. (Courtesy of Larry Simmons.)

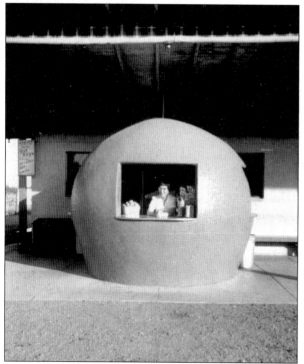

Giant Orange roadside stands were popular refreshment stops for travelers along old Highway 40, which led into Dixon. Because this was an era before automobiles were air conditioned, these stands were welcome stops where travelers could enjoy a 5¢ glass of fresh, cold, orange juice. Up to 12,000 oranges a week were juiced by hand to serve them. This Great Orange, owned by the George family, was located on Batavia Road and A Street. (Courtesy of Norman George.)

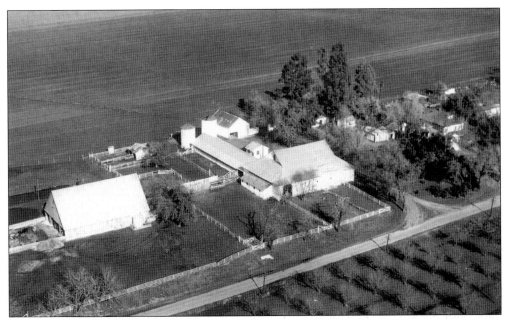

This is an aerial view of Watson Ranch, formerly the Ross Ranch. The top of this c. 1940 picture shows a field of alfalfa. An almond orchard stretches below the dirt road (now H Street). In 1903, E.R. Watson bought this land now known as Northwest Park.

Ward Watson's invention blew chopped alfalfa into the barn where it was dried. This enabled the alfalfa to be stored more quickly and efficiently. (Courtesy of Phyllis Watson Houlding.)

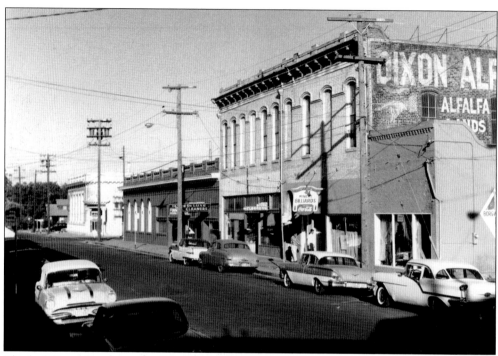

This building, referred to as the Dixon Opera House, was demolished in 1962. The opera house itself was located on the second floor with seating for 600 people. Note the ad for Dixon Alfalfa. Painting murals on the side of buildings was a common way to advertise. (Courtesy of Harold Axelson.)

This Dixon jail, which was adjacent to the fire house, was built in 1889. The new fire station was added in 1929. The Dixon City Council meeting room and city offices were located above the jail. Note the alarm tower in the background that was donated to the fire department by PG&E, who supplied the power. (Courtesy of Harold Axelson.)

Young high school students Alan Schmeiser and Wayne Stark conduct a chemistry experiment in Wes O'Neill's chemistry class, spring of 1951, and both attended UC Berkeley. (Courtesy of Grace O'Neill.)

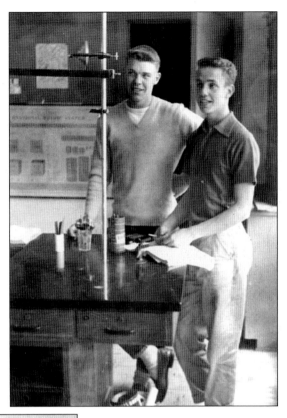

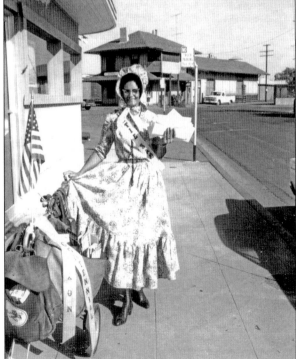

Even in this modern era, people have honored the past. Postal carrier Cathryn Smith, dressed for the 1968 Centennial Celebration, stands next to the Dixon Lumber Yard office. The lumber yard burned to the ground just after midnight, June 15, 1999, and the city lost a landmark. Note the railroad depot in the background.

Seven high school friends eager to promote the May Fair, from top to bottom, are Barbara Rayn Beckworth, Peggy Crockett Lusk, Millie Caruthers Rowbothan, Patsy Crockett Conley, Faye Crawford LeClair, Rhoda Covington Breuit, and Dolores Ferrero Garton. (Courtesy of Barbara Rayn Beckworth.)

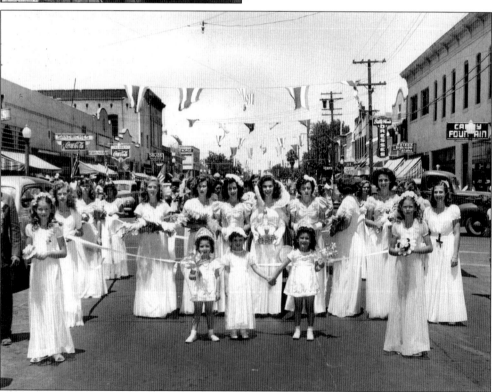

Queen Marie Sequeira and her attendants participating in the Holy Ghost Festival. It was an all-day event which began with a parade and ended at the fairgrounds for a barbeque.

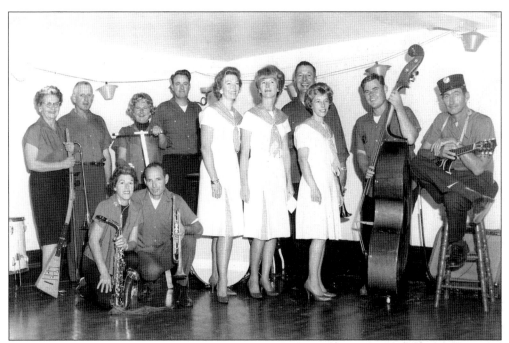

The chief of police, the fire chief, and the city manager were all members of the Dixon Phirehouse Philharmonics Jazz Band. When the band took trips, the mayor and the treasurer would go, too. Often these trips would include 60 to 80 people. According to Gladys Hanna, "The troublemakers were out of town and the town was safe." Band members, from left to right, are (front row, kneeling) Lou Mouvais and Harry Goodmanson; (singers in white) Gladys Hanna, June Pistor, and Ellie Jacobs; (back row) Danny Marks, Willie Marks, Della Kilkenny, Bill Fairfield, Ross Hanna, Bob "Porky" Harden, and Joe Bartholomew. Willie Marks and Ross Hanna formed this famous band c. 1960.

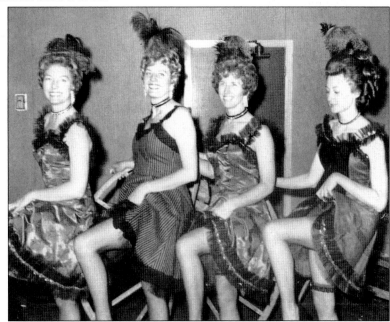

From left to right, can-can dancers Gladys Hanna, Jerrie Noren, June Pistor, and Ellie Schroeder Buhlert entertain for a Dixon Women's Improvement Club function.

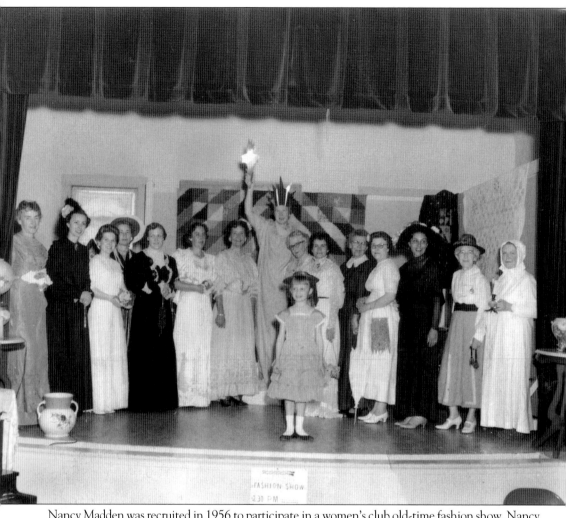

Nancy Madden was recruited in 1956 to participate in a women's club old-time fashion show. Nancy still loves the stage and stars in many shows in the Bay Area today. (Courtesy of Nancy Madden.)

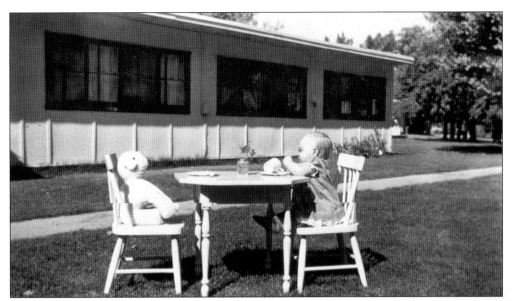

When Harold Axelson came to Dixon to teach math, he and his wife Phyllis and their 10-month-old daughter Sally lived in veteran housing provided on the property where the current band room is located at Dixon High School. Young Sally enjoys a tea party with her stuffed lamb on the lawn outside the housing project. (Courtesy of Harold Axelson.)

Other newcomers to Dixon were Wes O'Neill and Ira "Red" Finney with sons, Stephen and Dennis, in the spring of 1951. Wes began teaching the science classes and went on to become principal of both Dixon High School and C.A. Jacobs Intermediate School. "Red" Finney coached all the sports, but he was famous for training championship football teams and winning league titles. (Courtesy of Grace O'Neill.)

Even the border collies were moving ahead in this town. King, a border collie, was owned by Charlie Null. This dog, the most illustrious offspring of the famous Moss, had a chance at motion picture glory when he starred as a working dog in *Proud Rebel* along with Alan Ladd and Olivia DeHaviland (shown at left). He also appeared in television specials. King won one of the most hotly contested competitions, the Far Western Sheep Dog Trials, for seven consecutive years in the 1950s. (Courtesy of Virginia Null Hendrix.)

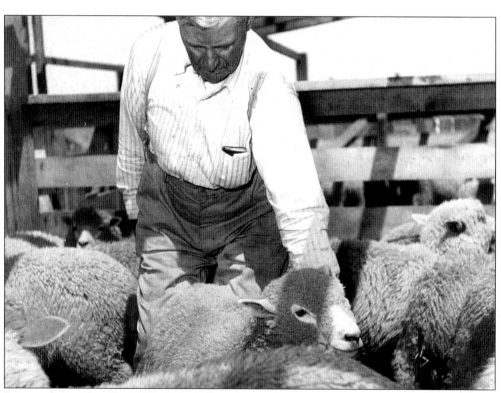

Business boomed in the 1950s. Bob Collier, shown above, was the largest lamb buyer in Dixon and did most of his trade at Dawson's. It was said that more sheep, wool, and grain dollars were traded over Dawson's bar than in any office. (Courtesy of Alan and Heidi Brown.)

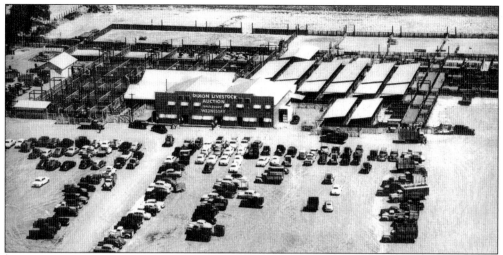

Pictured is an April 1950 aerial view of the Dixon Livestock Auction. Art and Homer Brown joined in this business endeavor in March 1939. Crowds would flock to the Dixon auction every Wednesday to purchase or sell their livestock. (Courtesy of Alan and Heidi Brown.)

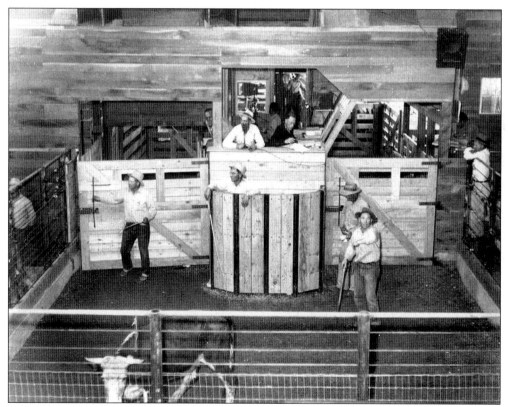

In April 1950, Herb Wedger, seated in the auctioneer's box in a white shirt, sits next to Stuart Grady as they sell cattle. (Courtesy of Alan and Heidi Brown.)

This precious old picture is of the Future Farmers of America, who dream of growing wheat, alfalfa, and raising their own cattle and sheep just as their ancestors did. The photo was taken in 1949. (Courtesy of Ardeth Sievers Riedel.)

The advent of subdivisions changed the face of Dixon. (Courtesy of Wes and Joanne Jacobs.)